Hebridean Images

To Margaret and Pat

and in memory of Isobel

Hebridean Images

Iain McGowan

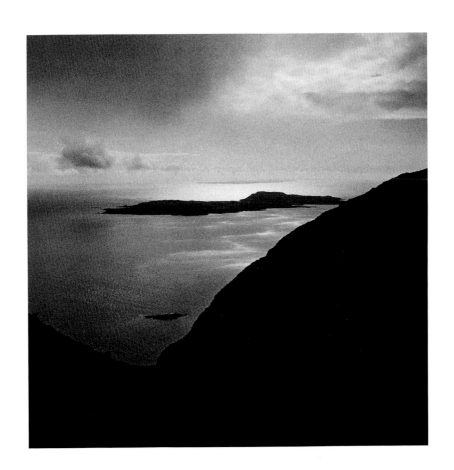

CREATIVE
MONOCHROME

HEBRIDEAN IMAGES
by Iain McGowan

Published in the UK by Creative Monochrome
20 St Peters Road, Croydon, Surrey, CR0 1HD.

© Creative Monochrome, 1993
Original photographs and text remain the copyright of
Iain McGowan, 1993.

British Library Cataloguing-in-Publication Data:
A catalogue record for this book is available
from the British Library

ISBN 1 873319 09 6
First edition, 1993

Printed in England by The Bath Press, Lower Bristol Road,
Bath.

Introduction

I can remember playing at a very early age with a wooden jigsaw puzzle of Britain in which all the counties were cut out and coloured separately. The piece forming the whole arc of the Outer Hebrides always fascinated me. This part of the puzzle had to be inserted into a large area of sea a long way from the rest of the country. Even during those tender years, it appeared different and out of the ordinary. This view has always remained with me, and I realise now that I have not been alone with such thoughts.

James Boswell was obviously equally fascinated when, in his *Journal of a tour to the Hebrides*, written in 1785, he stated:

> Doctor Johnson had for many years given me hope that we should go together and visit the Hebrides. Martin's account of these islands had impressed us with a notion that we might there contemplate a system of life almost totally different from what we had been accustomed to see; and to find simplicity and wildness, and all the circumstances of remote time or place, so near to our native great island, was an object within the reach of reasonable curiosity.

By 1873, in *The Hebrid Isles*, the Scottish poet Robert Buchanan had written:

> The British lover of beauty wanders far, but we question if he finds anywhere a picture more exquisite than opens out, vista after vista, among these wondrous Isles. Here year after year they lie almost neglected, seen only by the hard-eyed trader and the drifting seaman; for that mosaic being, the typical tourist, seldom quits the inner chain of mainland lakes, save, perhaps, when a solitary Saturday Reviewer oozes dull and bored out of the mist at Broadford or Portree, takes a rapid glare at the chilly Cuchullins, and, shivering with enthusiasm, hurries back to the South.

He continued with further detail:

> The heights of Rum, the kelp caverns of Islay, the fantastic cliffs of Eig, scarcely ever draw the sightseer; Canna lies unvisited in the solitary sea; and as for the Outer Hebrides – from Stornoway to Barra Head – they dwell ever lonely in a mist, warning off all fair-weather wanderers. A little, a very little has been said about these Isles; but to all ordinary people they are less familiar than Cairo, and farther off than Calcutta.

This somewhat poetic description echoes Samuel Johnson's own enthusiasm on his tour with James Boswell, when he refers to his reception on the islands:

> The hospitality of this remote region is like that of the golden age. We have found ourselves treated at every house as if we came to confer a benefit. Company is, I think, considered as a supply of pleasure and a relief of that tediousness of life which is felt in every place elegant or rude.

Opinions have, however, varied. John Spencer-Stanhope complained in 1806:

> Talk not to me of bad roads! What can you know of travelling, who have not gone starving, frozen, sleepless, and supperless, in real danger of death by

bog, torrent or exposure. Such is the journey to the Hebrides, and none but the hardy need undertake it.

From these and other reports from those early intrepid travellers, it is clear that the Hebrides have always been regarded as a place apart. Here was somewhere few outsiders had ever reached. Before the nineteenth century, only two reasonably descriptive books (Dean Monro and Martin Martin) had been written about the Isles. Whilst it was not unusual in the second half of the eighteenth century to find naturalists and explorers beginning to set foot in various, previously unknown, parts of the globe, the rock-fastness of the Cuillins, the caves of Staffa and the isolated archipelago of St Kilda had yet to be discovered by any but the very privileged few. Despite lying just a few miles off the west coast of Scotland, there was still the barrier of an uncertain storm-tossed sea, a strange foreign language spoken by the 'natives' and wild, windswept landscapes.

The west coast of mainland Scotland is further from London than many European capitals and, for anyone with a fear of the unknown or a preference for warmer climates, it was clear in which direction their journeys would take them. The early travellers were generally well educated and well off and consequently the gulf between themselves and the Hebridean islanders, with their individual Gaelic identity and Celtic ancestry, must have seemed enormous.

The long, hard period of the nineteenth century with its recurring famines and shameful clearances did little to bring the islands closer to the mainland. The continuing oppression of the people and transportation of whole communities forced onto emigrant ships were acts which most people were strangely ignorant of, or simply turned their backs on. It was only when the gunships and Marines arrived off Skye in 1884 to attempt to quell the seething discontent among the remaining islanders that the general public at last began to take notice and to enquire as to where these isolated islands were.

Perceptions of the beauty of nature have also changed over the centuries. Consider Walter Scott's vivid description of Loch Coruisk on Skye in 1814:

> Rarely human eye has known
> A scene so stern as that dread lake,
> With its dark ledge of barren stone....

This was hardly likely to encourage further visitors and is a far cry from present day appreciations. Similarly, James Hogg's account of a voyage to Harris in 1804:

> ...the elements were in a tumult and seemed to be taking flame; the pale, vivid bolts bursting from the rolling clouds added horror to the scene, and to minds nearly stupefied, the sea seemed covered with sparkling fire, an appearance quite new to us, and which we had no conception of, though we were told it was quite common in great storms.

Fortunately, we see things in a different light now. The ever changing mood of weather has become an attraction. From the mainland, the islands seem to come and go. Sometimes they are boldly silhouetted in evening light, sometimes hidden by drifting curtains of soft Atlantic rain, sometimes faint and mysterious through a

blanket of mist. They are always, however, alluring; exercising a fascination and attraction that is unique among islands. One either loves or hates them. Whether it is the still unaltered, stunning scenery, the mysterious quality of light, the friendliness of the people, or just being the final outpost of western Europe, there is a certain indefinable something that draws one back.

Sometimes, of course, the returning islander or visitor simply cannot get back – the sea between mainland and islands playing a treacherous game against all. One day it can be gloriously calm without a breath of wind, followed by another of startling contrast. The wind can whip the waves to house height and all sailings are then cancelled for an indefinite period.

In many parts, the landscape is totally barren and treeless; the sea is never far away and the wind almost constant. Yet a sense of space and freedom prevails as does the feeling of a strong identity. The islands are the surviving heartland of Gaelic, still spoken as a first language by a considerable proportion of the native islanders. After a long period of decline, it is to be hoped that the struggle to keep the Gaelic language and tradition alive is now being won: an indication of the strong character of the people in the face of erosion by the media and other outside influences.

There is still that timeless quality that John MacCulloch found during his visits in the early nineteenth century:

> Time is never present, but always past or to come. It is always too soon to do anything, until it is too late; and thus vanishes the period of weariness and labour and anxiety and expectation and disappointment which lies between the cradle and the grave.

And yet time is all around. The past is there in the shape of the amazing rock formations which enthused the early geologists, the ancient standing stones, Iron Age duns and ruined castles. Empty, deserted glens still reveal their secrets of former habitation with lichen-encrusted stones from the old Black houses, lazy beds on the hillsides and tracks to the summer Sheilings: the sad, tragic reminders of a people swept to the new worlds of Canada and Australia.

The future too can be seen in the ever increasing search for oil and natural fuel reserves. This will perhaps bring more changes in the forthcoming years than have been seen in the span of the last few centuries.

These elements of continuity and potential change have provided the photographer with much to record. At the end of the last century, George Washington Wilson's hand-coloured glass plates captured the strength of timelessness, his portraits of the people appearing in a manner that would be equally typical of their fathers and forefathers. The simplicity of dress, the few personal possessions, the nature of their domestic surroundings: all tell the same story.

A few years later M E M Donaldson was to drag her 'Green Maria' trolley full of photographic equipment around the Highlands and Islands to depict a similar type of image. Paul Strand's beautiful photographs of South Uist clearly demonstrate the warmth and dignity of the people and pride in their homeland

and crofting lifestyle. In recent years, Gus Wylie has shown the beginnings of a progression of change into the elements of an older lifestyle, not only by the manner of his portraiture, but also in his landscapes and interior studies.

Probably it was this conflict of timelessness and progression, a love of open spaces and, of course, my earlier puzzled curiosity, that brought me to the islands to take the pictures shown in this book. I have always felt an enjoyment of form, mood and atmosphere and above all, use of light in the landscape. The sometimes wild, almost primeval land forms of the Hebrides, with their constantly changing light, give considerable scope for this type of photography. This, coupled with the immediate warmth of the people, their tenuous hold on the land and the ever present evidence of the past, gave me the inspiration for the photographs.

It is not intended that these pictures should act in the form of a guide to the Hebrides: there are many places and individual islands not recorded here and, in any case, there are far better books available for this purpose. I hope, however, that the images contained here will bring out that certain atmosphere and quality of life that is unique among the Hebrides; the difference that those earlier writers were so enthusiastic about. By the use of both landscape and portrait studies, together with a considerable number of smaller details, I have attempted to capture the essence of these islands. All the parts add up to a whole: somewhere to be recorded before too many traditional values are eroded; somewhere that is literally a place apart.

SELECT BIBLIOGRAPHY

Banks, Noel, *Six Inner Hebrides*, David & Charles, 1977
Cooper, Derek, *Road to the Isles*, Richard Drew Publishing, 1990
Cooper, Derek, *Skye*, Routledge and Kegan Paul, 1970
Donaldson, M E M, *Wanderings in the Western Highlands and Islands*, Alexander
 Gardner, 1921
Hedderwick, Mairi, *An Eye on the Hebrides*, Canongate, 1989
MacLean, Malcolm, and Carrell, Christopher, *As an Fhearann*, Mainstream
 Publishing, 1986
MacLeod, Kenneth, *The Road to the Isles*, Robert Grant & Son, 1927
Murray, W H, *The Hebrides*, Heinemann, 1966
Murray, W H, *The Islands of Western Scotland*, Eyre Methuen, 1973
Strand, Paul and Davidson, Basil, *Tir a' mhurain*, MacGibbon & Kee, 1962
Thompson, Francis, *The Uists and Barra*, David & Charles, 1974
Urquhart, Judy and Ellington, Eric, *Eigg*, Canongate, 1987
Wade Martins, Susanna, *Eigg – An Island Landscape*, Countryside Publishing, 1987
Wylie, Gus, *The Hebrides*, Collins, 1978
Wylie, Gus, *Patterns of the Hebrides*, A Zwemmer, 1981

Images

Mo shoraidh slan leat 'sgach ait an teid thu!

(May joy await thee where'er thou sailest!)

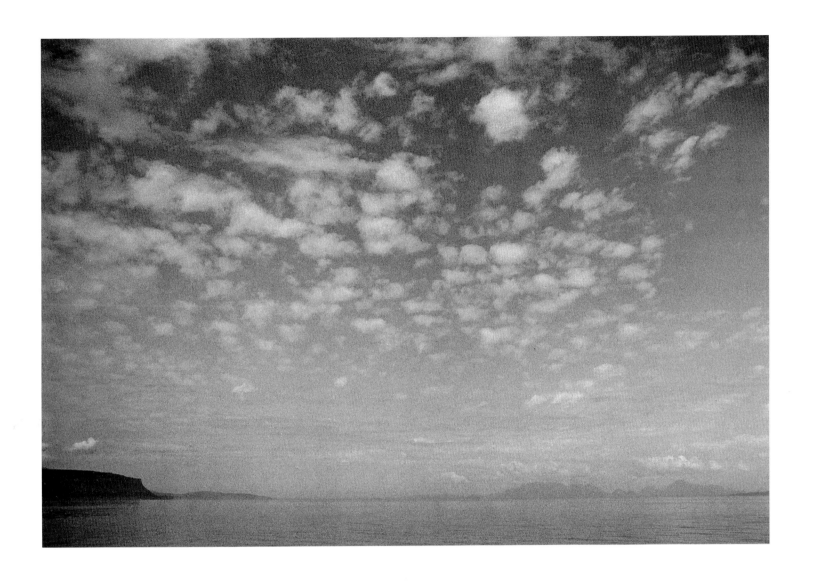

Sea crossing to Eigg from Arisaig

"The isle to which we were going is classic ground; the name of each rock, mountain and lake, being connected with some fact related in the traditions of which the poems of Ossian form a part."

Necker De Saussure, *A Voyage to the Hebrides*, 1822

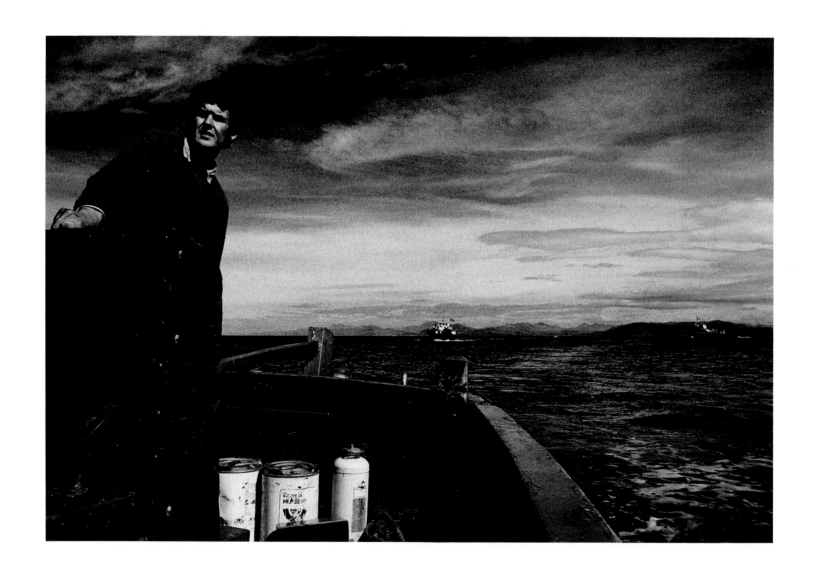

Simon Helliwell, Ferryman, Eigg

Travelling to Eigg from Mallaig still requires a transfer at sea from MacBrayne's ferry, Lochmor, to the island 'flit' boat. This is due to lack of deep berthing facilities at the island pier. The transfer can cause much amusement and occasional consternation to summer visitors. However, most supplies to the island also have to be handled in the same manner, not just during the calmer summer months, but throughout the whole year. Planned improvements will therefore be welcome. The departing Lochmor and the alternative ferry from Arisaig, the Shearwater, can be seen in the background of this photograph. In addition to his duties as ferryman, Simon is the island's builder and cabinet-maker.

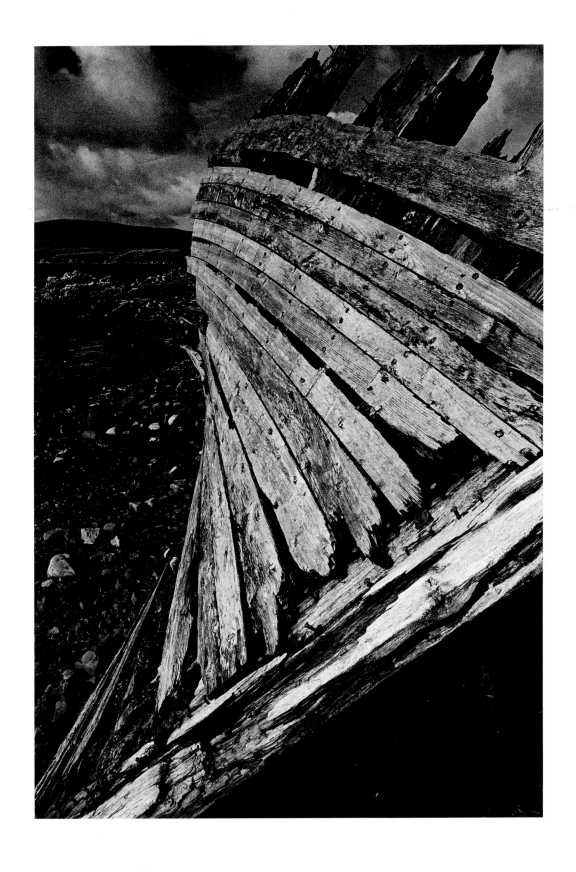

Rotting boat, Claigan, Skye

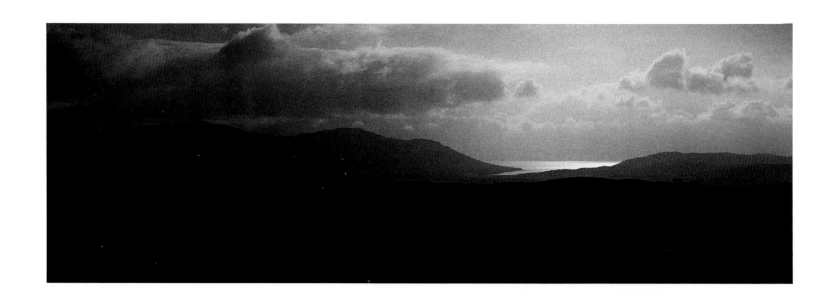

Distant sea, Heast, Skye

"The cold cheerless rocks, the treeless desolation, the perpetual tendency of the clouds to rest, as if it was their home, on the tops of the hills, the great corries into which weather has hollowed one side of most of the mountains, the utter want of natural verdure, the grey, benty colour of the always drenched pasture, the absence of villages and of all human appearance – these things mark Skye as the asylum of dreariness."

Lord Cockburn, *Circuit Journeys*, 1842

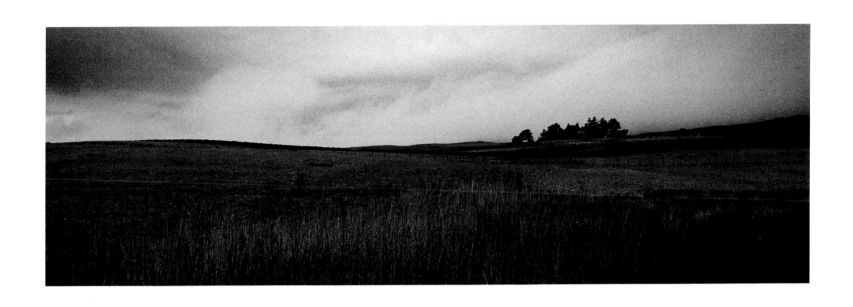

Croft land, Eigg

"Egge....gude mayne land, with ane paroch kirk in it, with mony solenne geis; very gude for store, namelie for scheip, with ane heavin for hieland Galayis."

Dean Monro, *A Description of the Western Isles of Scotland called Hybrides*, 1549

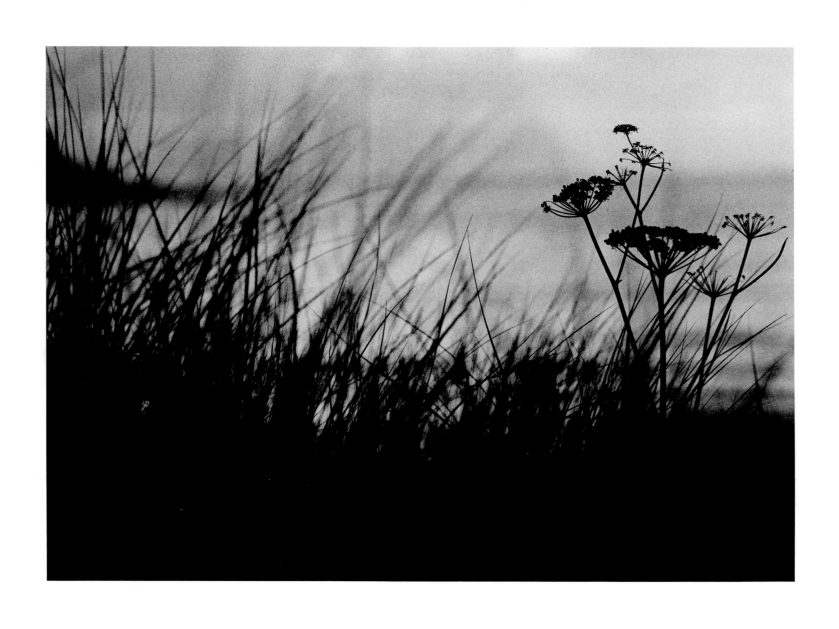

Marram grass and hogweed, Scarista, Harris

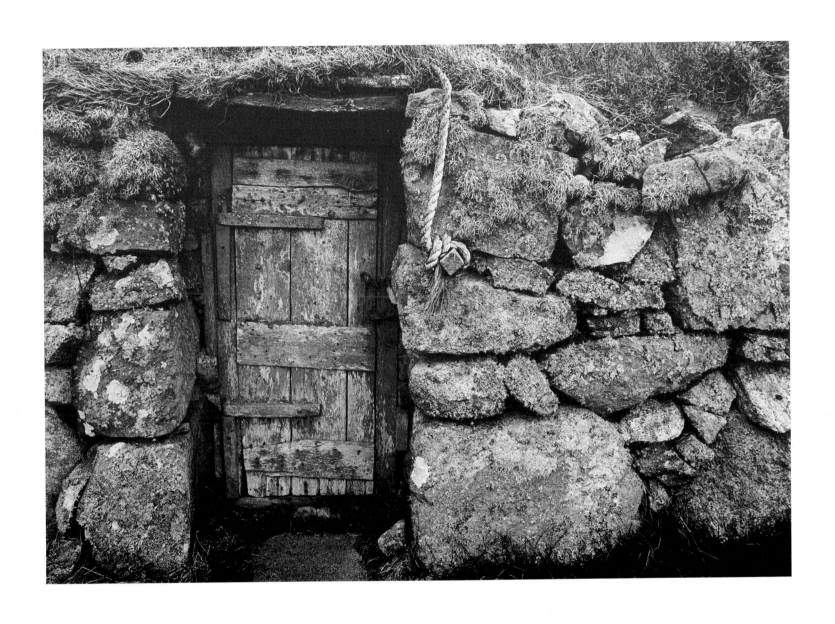

Door, South Lochboisdale, South Uist

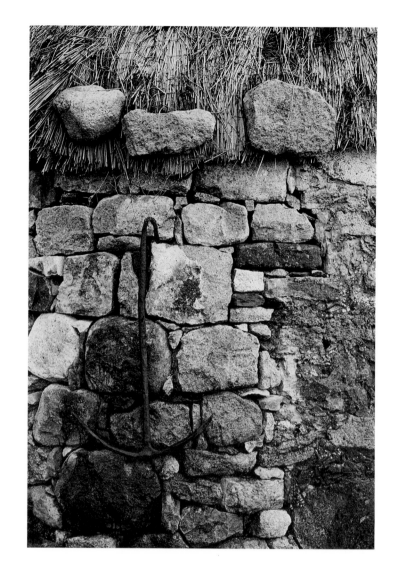

Walls, Luib, Skye

"The walls of the cottages in Skye, instead of being one compacted mass of stones, are often formed by two exterior surfaces of stone, filled up with earth in the middle, which makes them very warm. The roof is generally bad. They are thatched, sometimes with straw, sometimes with heath, sometimes with fern. The thatch is secured with ropes of straw, or of heath; and, to fix the ropes, there is a stone tied to the end of each. These stones hang round the bottom of the roof, and make it look like a lady's hair in papers; but I should think that, when there is wind, they would come down, and knock people on the head."

James Boswell, **The Journal of a tour to the Hebrides**, *1785*

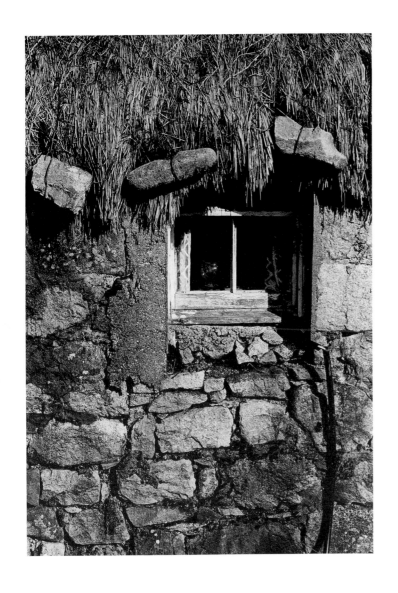

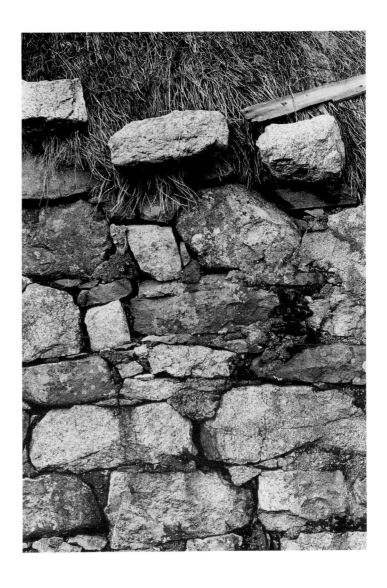

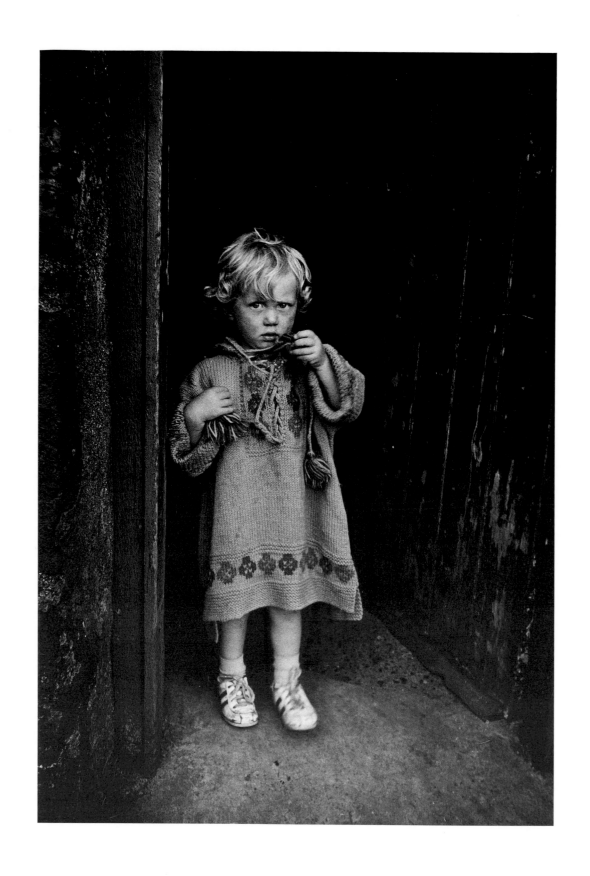

Sarah Boden, Cleadale, Eigg

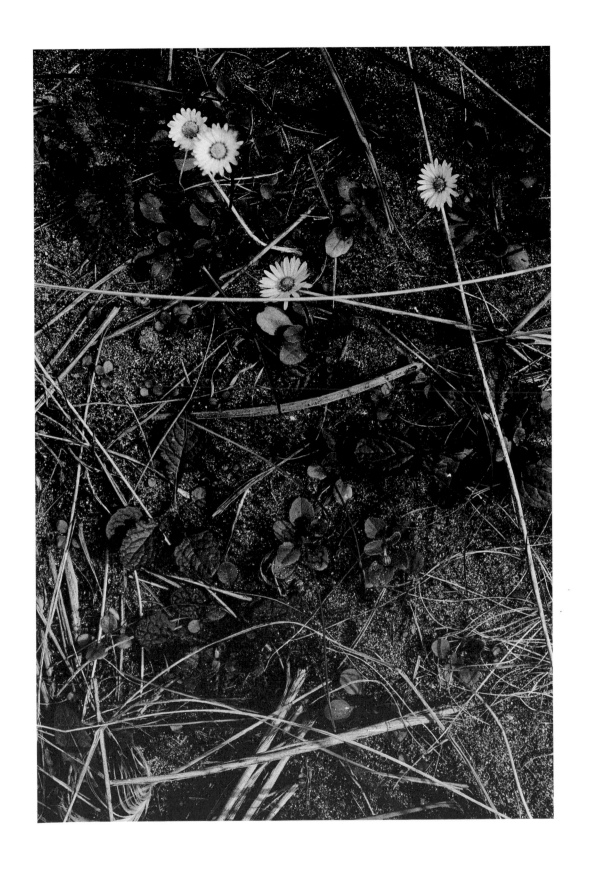

Beach detail, Ormiclate, South Uist

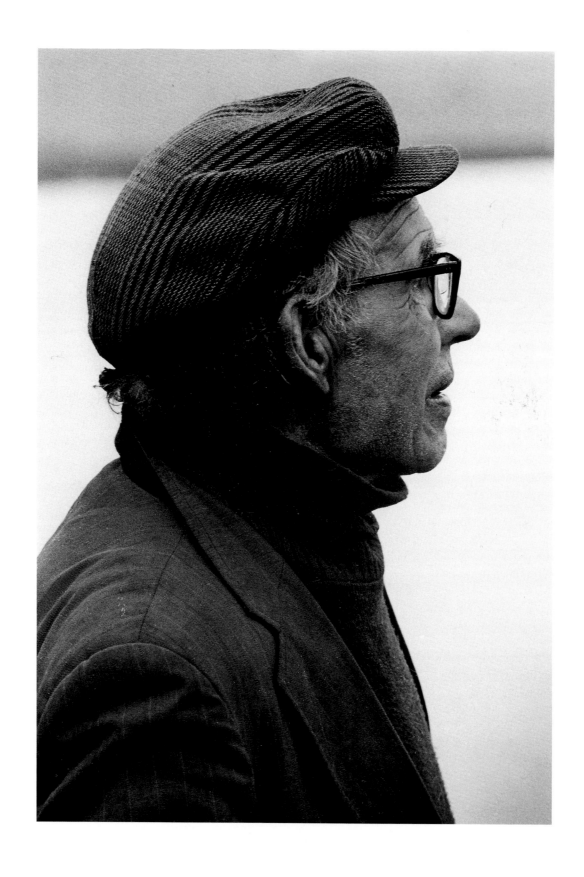

The late Lachlan MacDonald, Crofter, Cleadale, Eigg

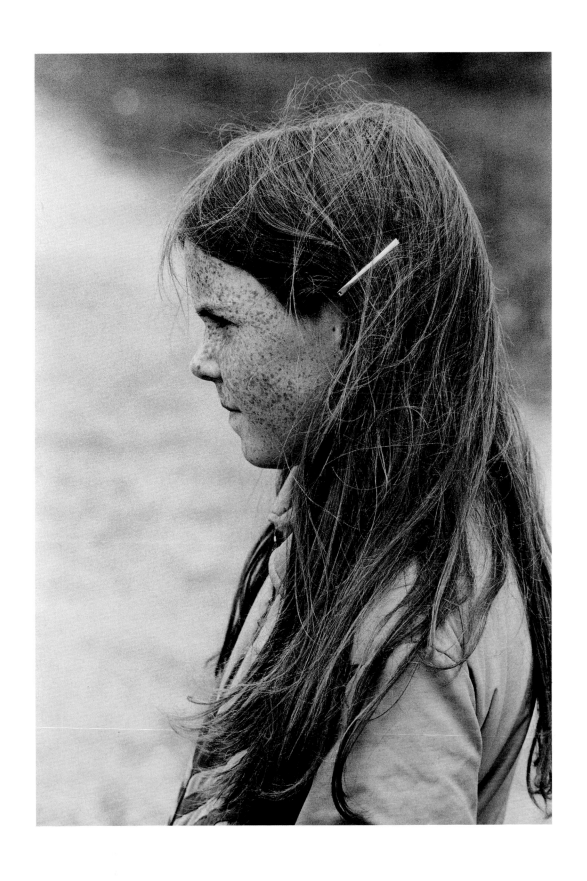

Fiona Kirk, Laig, Eigg

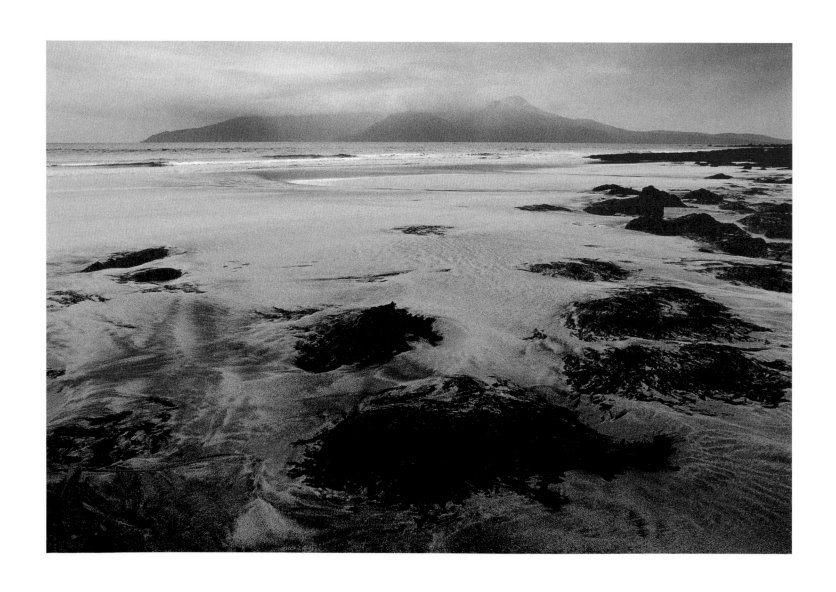

Towards Rhum from Laig, Eigg

The Hebrides boast of many of the finest beaches in Europe. Simply because summer temperatures rarely reach soaring heights, the bikinis, sun umbrellas and barbecues are missing: a credit to the much maligned weather. Images such as this can be found without another soul in sight.

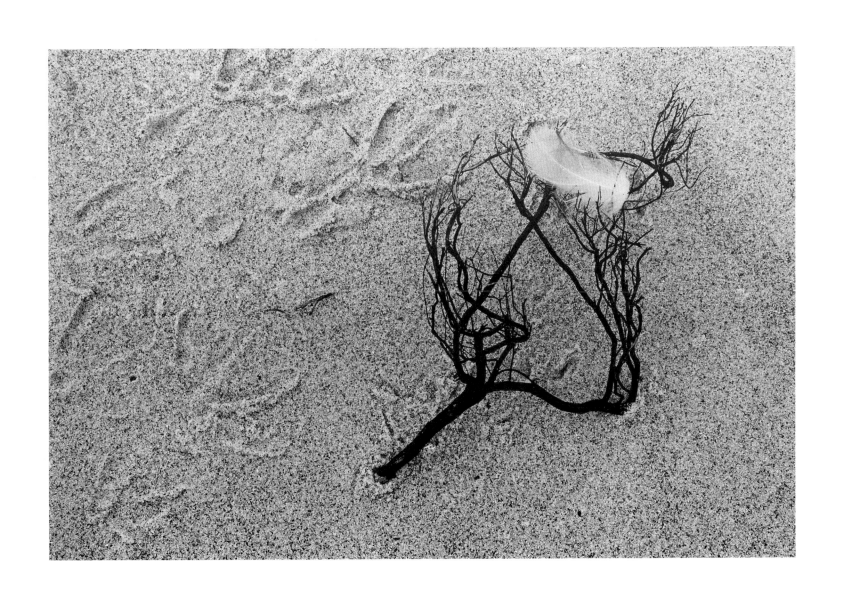

Beach detail, Ardskenish, Colonsay

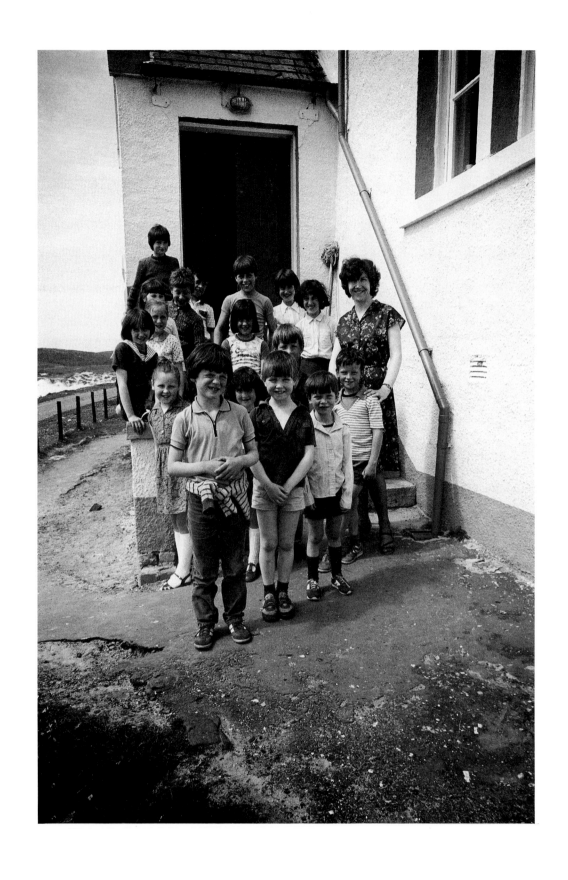

The school, Vatersay

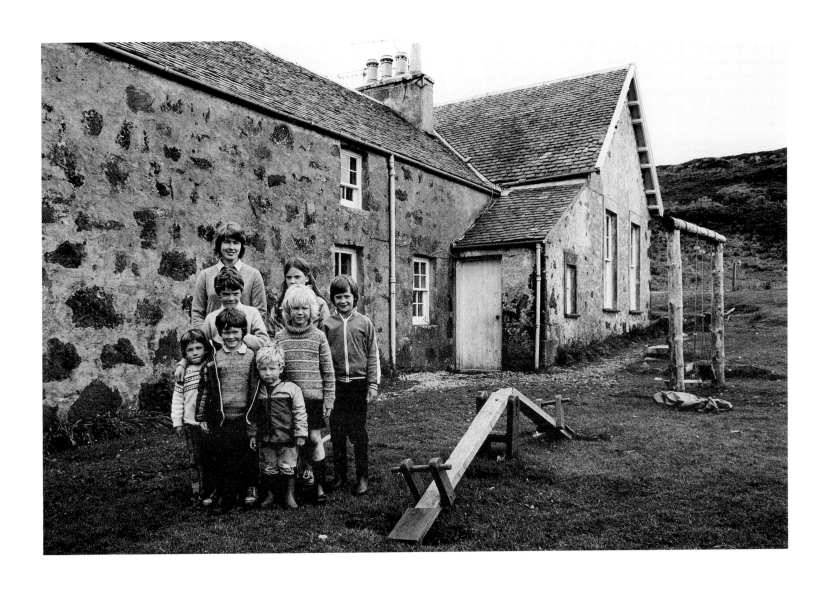

The school, Eigg

As island communities have tended to shrink, so have the number of school pupils. On small islands such as Vatersay and Eigg, school closures have been a real threat. However, population levels are beginning to stabilise and it is hoped that the decline has been halted. It would be encouraging to think that the policy of all teaching being conducted in English has finally been halted as well.

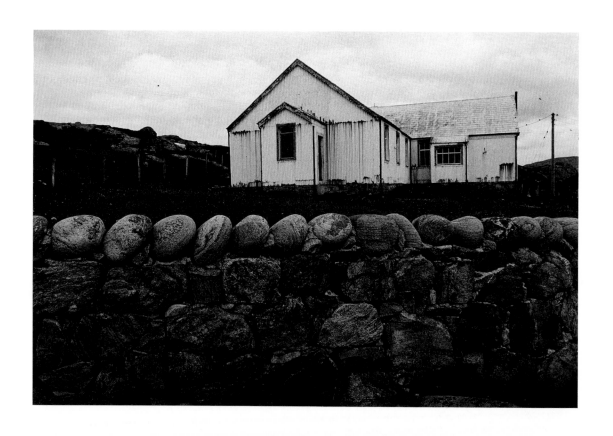

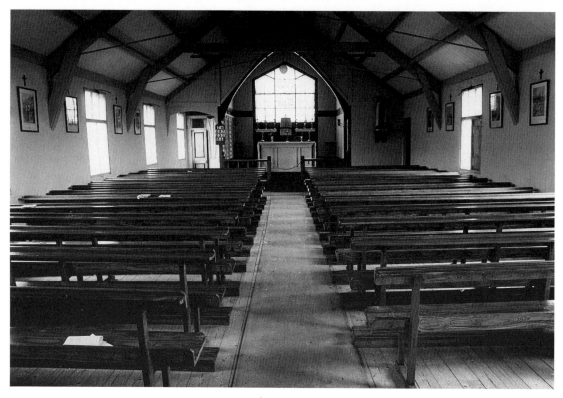

The church, Vatersay

Church detail, Vatersay

There are very few ancient Hebridean churches still in use, notable exceptions being Rodel Church on Harris and Iona Abbey. Most, however, are in ruins and therefore the majority of buildings now used are comparatively modern. Vatersay is a typical example of the more recent buildings. Despite its rather stark exterior, the interior is simple and uncluttered with a feeling of sincerity found lacking in many larger establishments elsewhere.

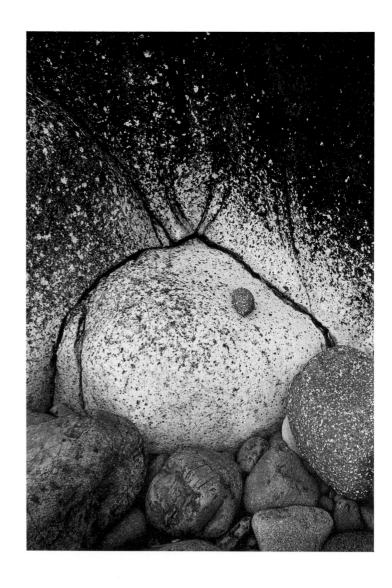

Rocks, Sgorr Sgaileach, Eigg

"He would be a happy geologist who, with a few thousands to spare, could call Pabba his own. It contains less than a square mile of surface; and a walk of little more than three miles and a half along the line where the waves break at high water level brings the traveller back to his starting point; and yet, though thus limited in area, the petrifications of its shores might of themselves fill a museum. They rise by thousands and tens of thousands on the exposed planes of its sea-washed strata, standing out in bold relief, like sculpturings on ancient tombstones, at once mummies and monuments – the dead, and the carved memorials of the dead. Every rock is a tablet of hieroglyphics, with an ascertained alphabet; every rolled pebble a casket, with old pictorial records locked up within."

Hugh Miller, *Cruise of the Betsey*, 1858

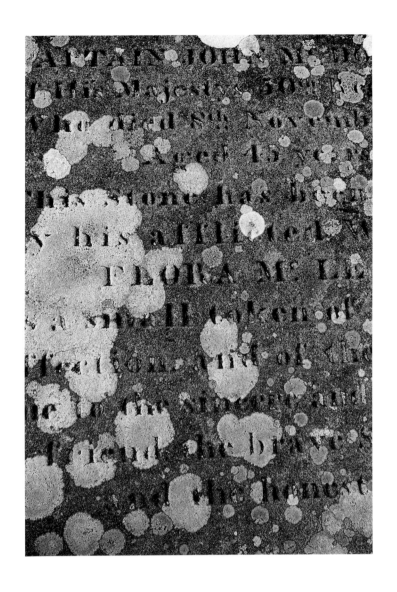

Gravestone, Cill Chriosd, Skye

Fingals Cave, Staffa

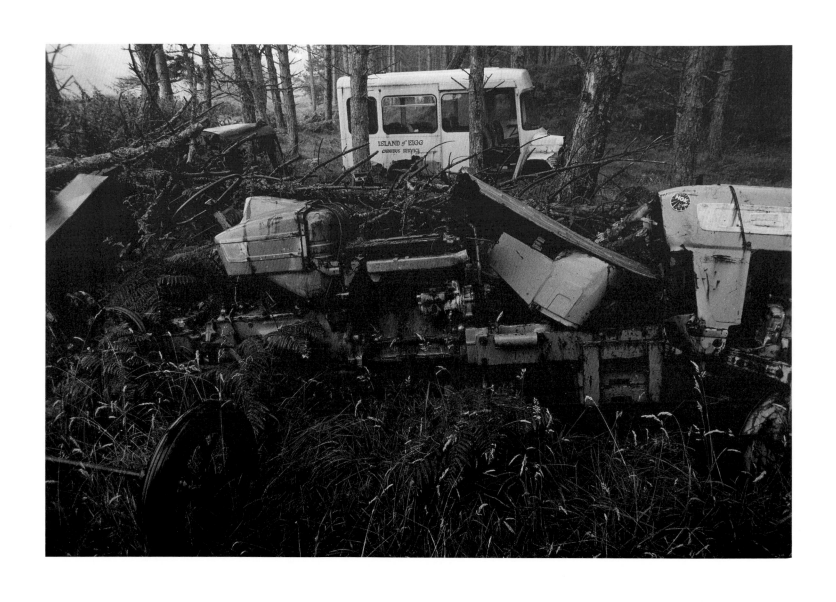

Final stop, Island of Eigg omnibus service

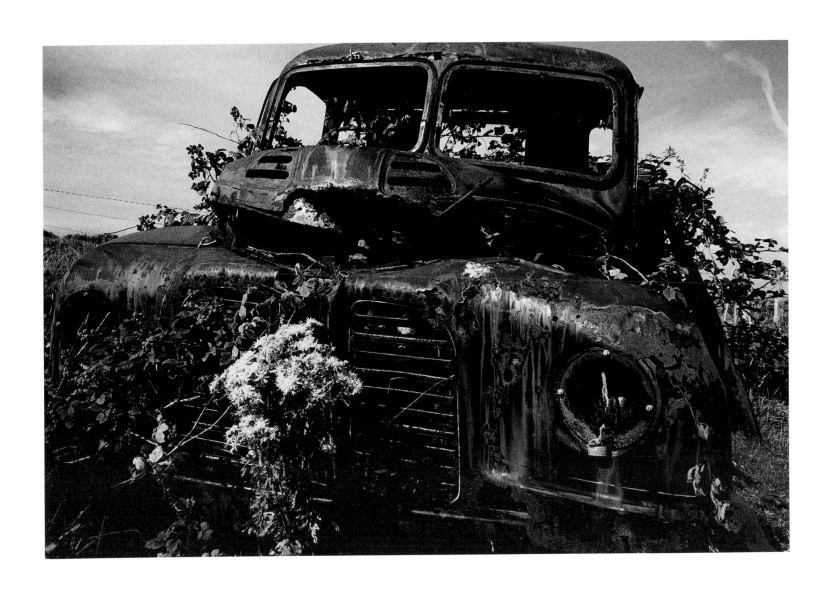

Abandoned lorry, Cleadale, Eigg

With no satisfactory means of waste disposal, many discarded vehicles just rest at the roadsides, gently rotting away in the salt-laden atmosphere. For a time, however, they still have a use – as a marvellous source of blackberries in the summer!

"The mountains abound in deer, hare, and wild fowl; the fields in grain, hay and pasturage; the gardens in fruits and vegetables; the rivers in trout and salmon; the sea in herrings and white fish. Such, with the additional circumstance of a well stocked cellar, are the felicities of this very remote and almost inaccessible corner."

John Knox (near Bracadale), *A Tour through the Highlands of Scotland*, 1787

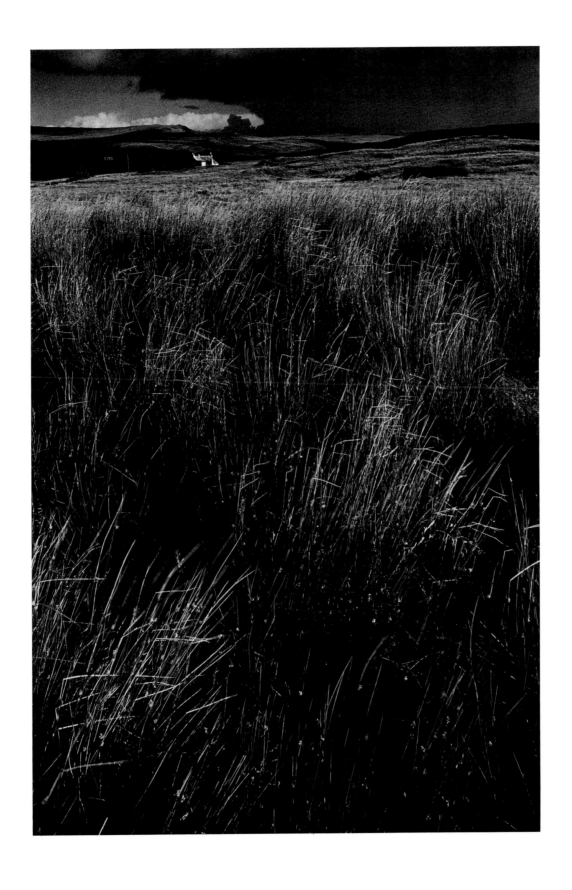

Near Bracadale, Skye

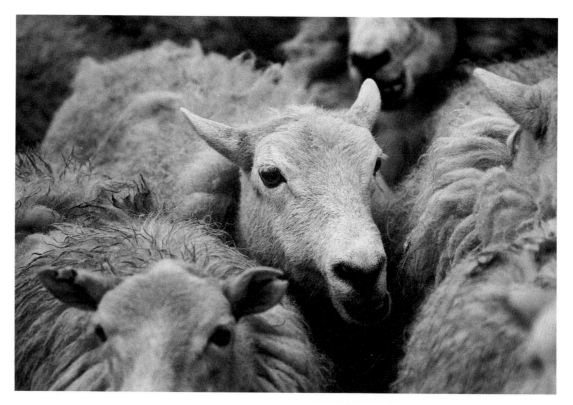

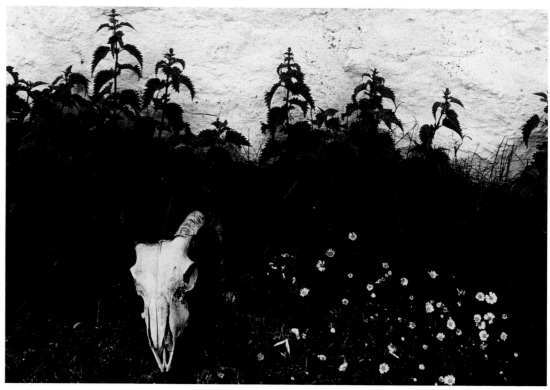

(top) **Sheep, Sligachan, Skye**
(below) **Sheep skull, Balevullin, Tiree**

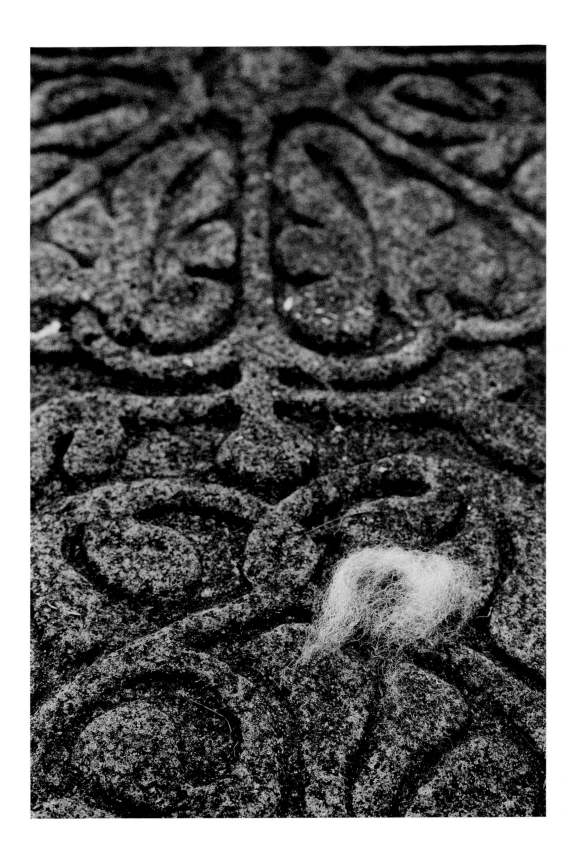

Wool on stone carving, Kildonnan, Eigg

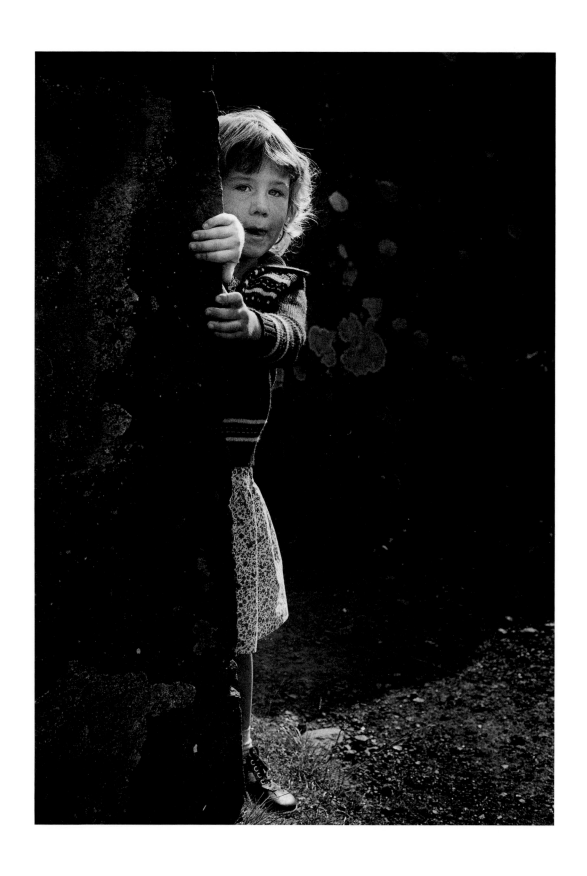

Emma Allen, Cuagach, Eigg

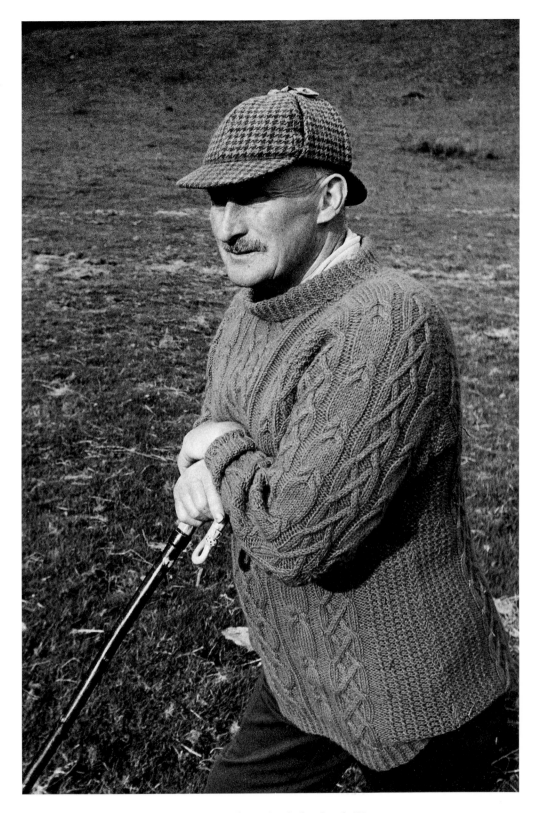

Pat MacNab, retired shepherd, Eigg

Pat, born on Eigg, left for the mainland at the age of four, not returning until well into his fifties. Despite his long years in a rural, relatively secluded life, he can hold a conversation on well nigh any subject and is widely respected and written about wherever he travels. His fondness to "get cracking" recalls many happy memories in the kitchen of Laig Farm.

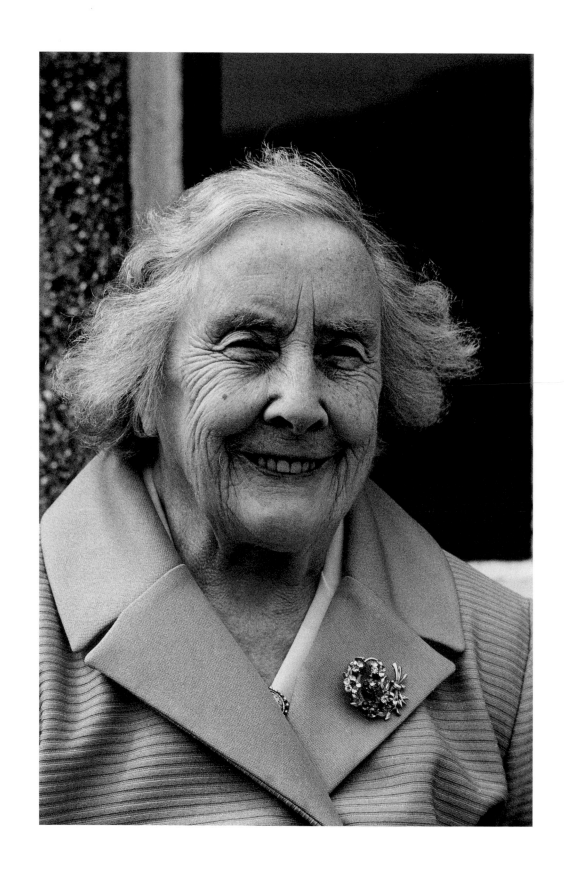

Mary Kirk, Laig, Eigg

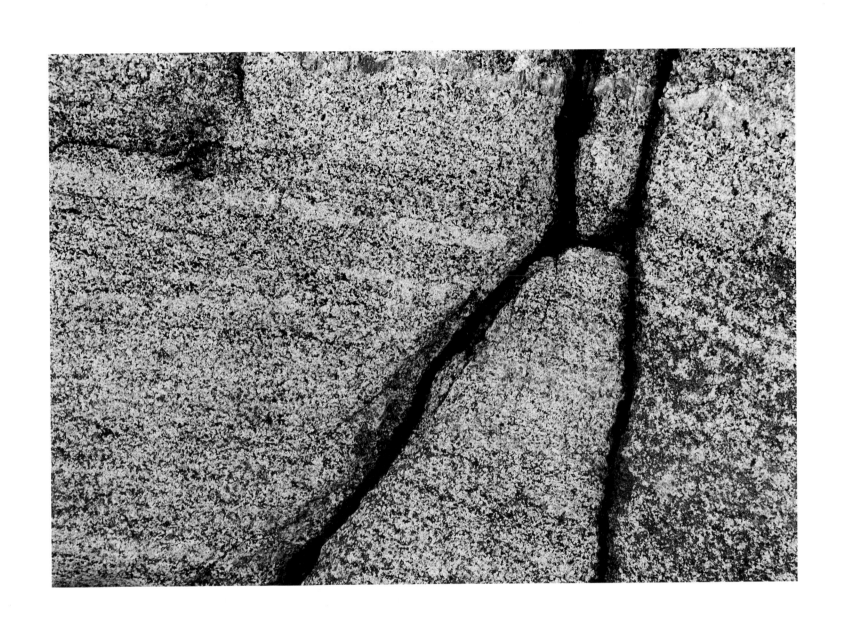

Rock strata, Kilpheder, South Uist

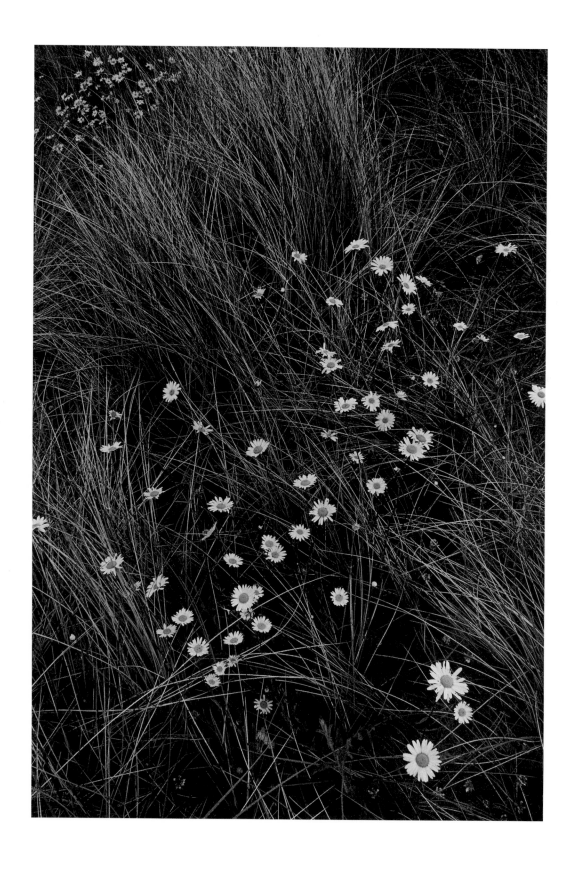

Daisies, Luskentyre, Harris

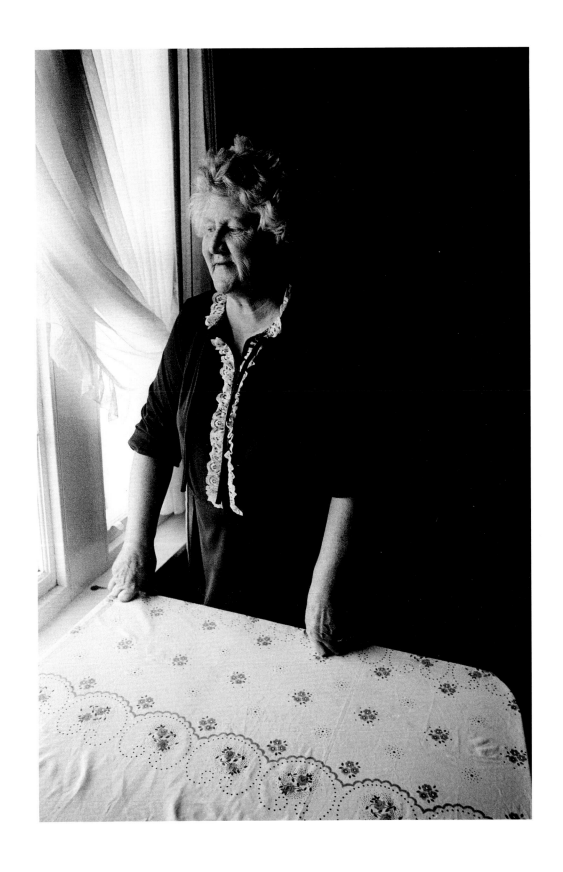

Mary MacNeil, Borve, Barra

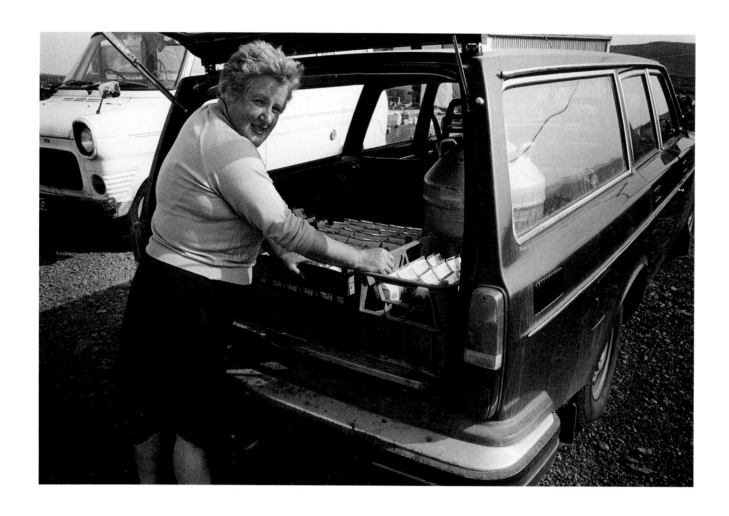

Milk delivery, Mrs MacKinnon, Upper Kilhatten, Colonsay

*In order to survive the many harsh conditions of Hebridean life, the communities are of
necessity closely knit. Apart from the usual household daily chores and a bed and breakfast
business, Mrs MacKinnon still finds time to deliver the milk to all her neighbours.*

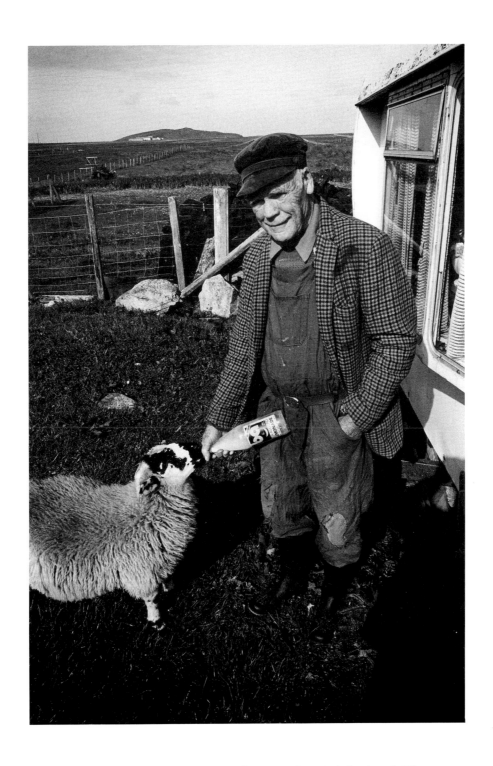

Milk delivery, Mr Steele, Crofter, North Boisdale, South Uist

"If much refinement and elegance is not to be seen, there is at least abundance of substantial commodities; no lack of black-faced mutton and poultry with the addition of salmon, and various other excellent fish on the sea coasts; and, indeed, scarcely a burn but affords a trout. The traveller may everywhere calculate on the luxuries of tea and sugar, and general loaf-bread or biscuits, eggs and milk, with whisky etc, always in abundance."

George and Peter Anderson, *Guide to the Highlands and Islands*, 1834

Donald MacDonald, thatcher and gaelic writer, South Lochboisdale, South Uist

Three reminders of a morning spent with this memorable man – "we are a people locked up in the Atlantic"

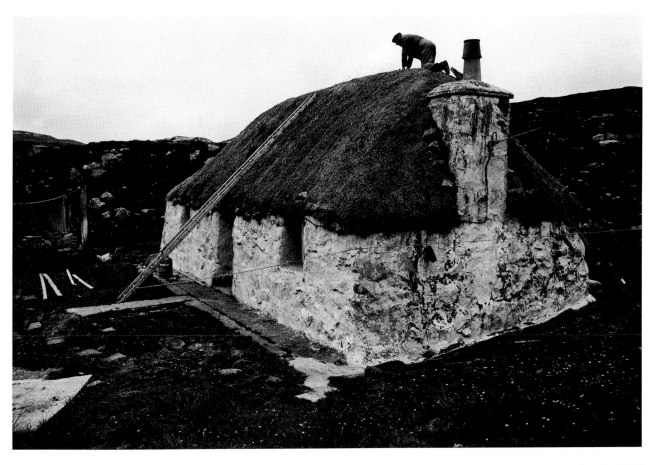

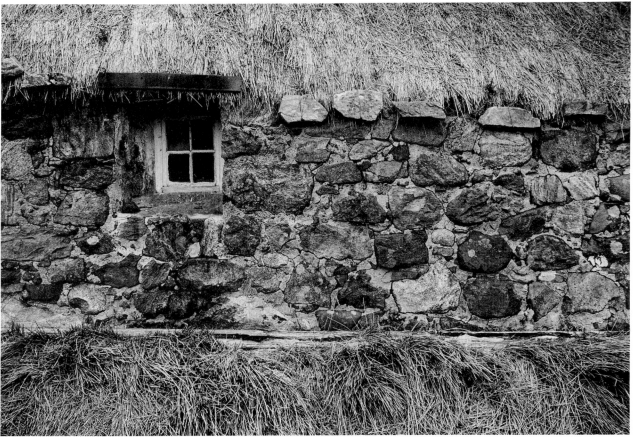

47

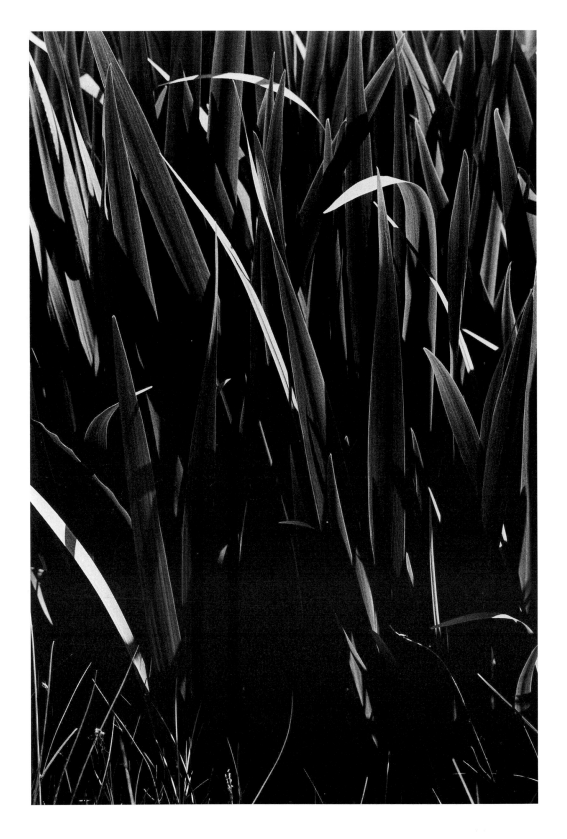

Reeds, Uisken, Mull

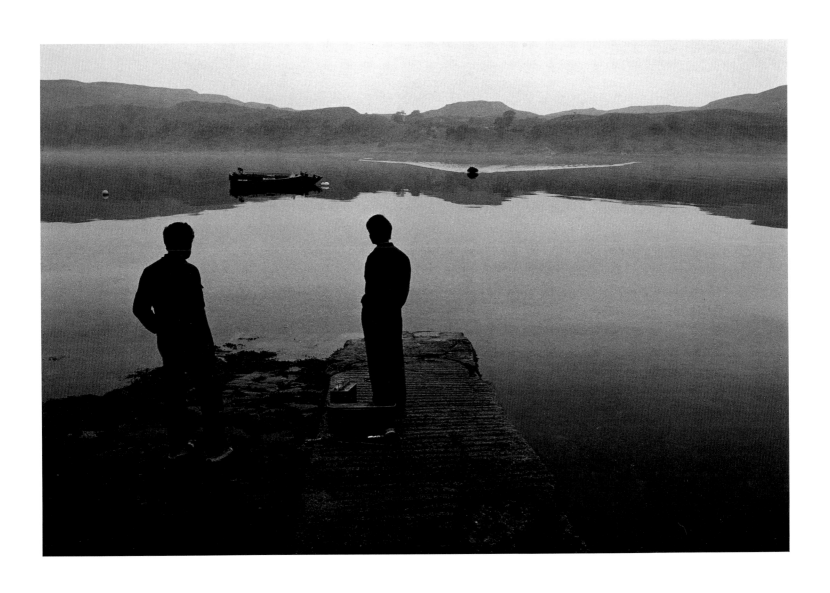

Waiting for the ferry, Kerrera

Kerrera ferry lies just two miles from Oban and the crossing takes only a few minutes. The island, however, is as peaceful as any within the Hebrides and all the less desirable trappings of modern life have been left far behind by the time the ferry has landed.

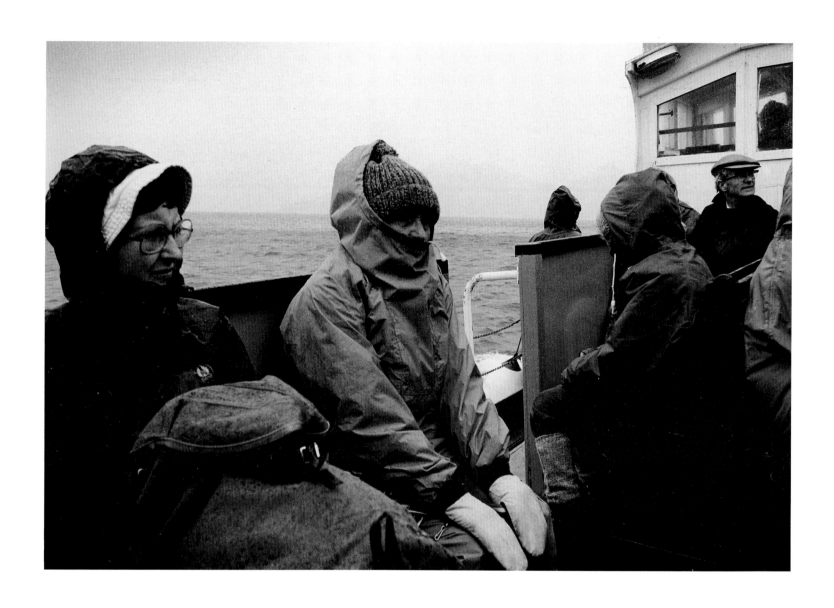

Frozen day trippers to Rhum

The ferry crossings to and around The Small Isles are often subject to rapidly changing weather conditions. By necessity, the boats are generally small and it is not at all unusual to commence a journey on a gloriously sunny, calm day, only to return in quite violent and chilly squalls with a sickening swell on the water.

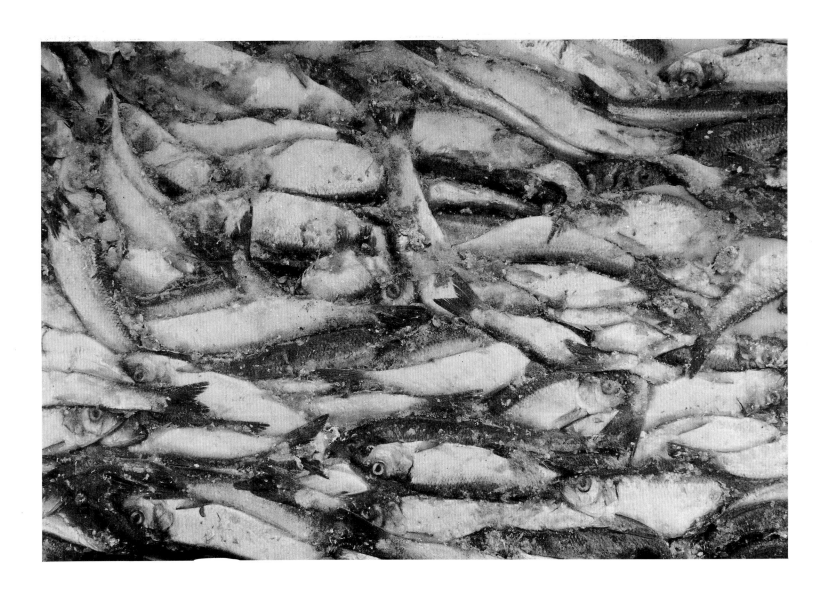

Frozen fish, Scalpay

"You have no idea, sir, how good boiled salmon is. To acquire this, three things are requisite – a stormy voyage, then a rustic entertainment without knives and forks and chiefly the utter and absolute and animated freshness of the fish."

Lord Brougham, *Tour in Western Isles, including St Kilda in 1799*

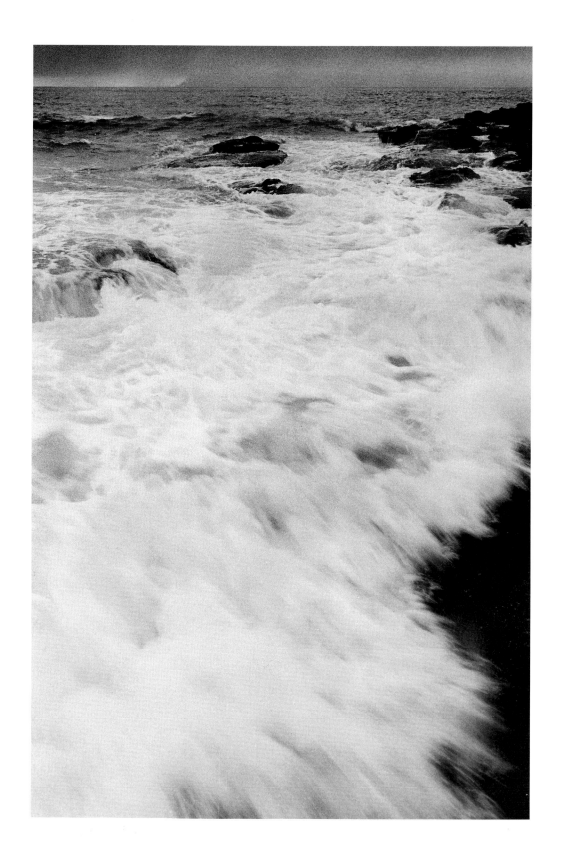

Wet day, Eigg

"It was a very wet stormy day. I employed a part of the forenoon in writing this journal. The rest of it was somewhat dreary, from the gloominess of the weather, and the uncertain state in which we are in, as we could not tell but it might clear up every hour. Nothing is more painful to the mind than a state of suspense, especially when it depends upon the weather, concerning which there can be so little calculation."

James Boswell, *The Journal of a tour of the Hebrides*, 1785

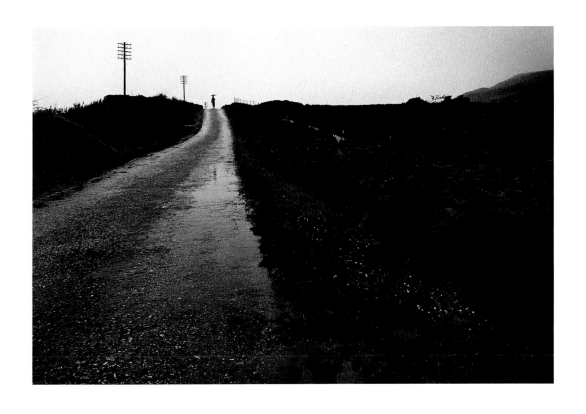

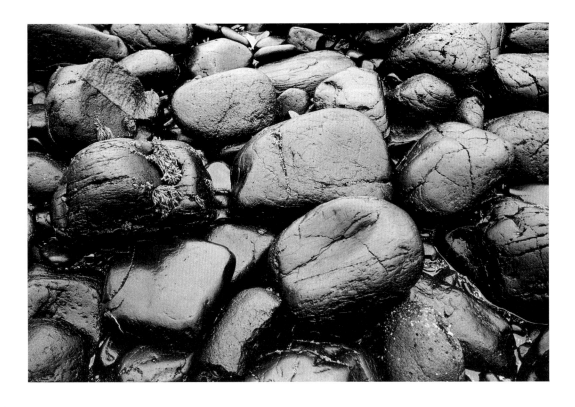

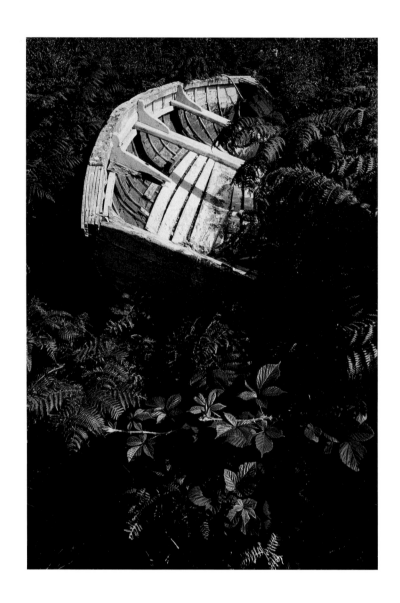

Abandoned boat, Galmisdale, Eigg

A boat that was involved in a tragic accident several years ago. Now beached in thick undergrowth above the old Eigg pier, the boat has slowly rotted ever since.

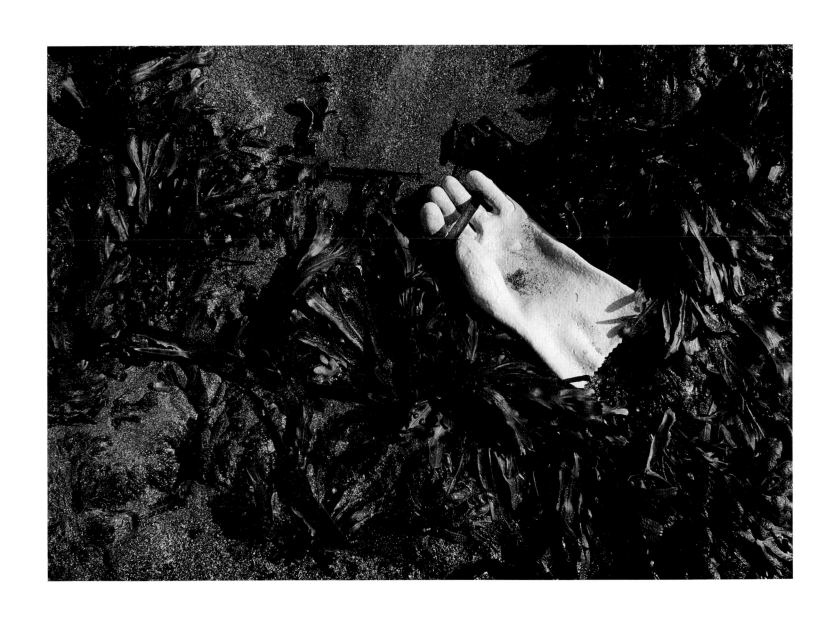

Glove on beach, Eriskay

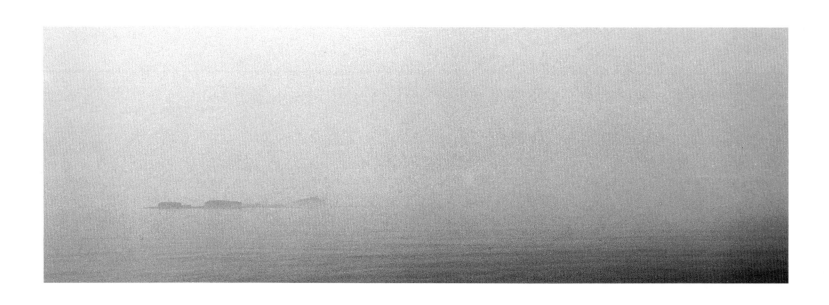

Mist and calm, Treshnish Isles

"The rest of the sail was delightful. We moved over a sea nearly of glass, past places, but particularly past islands and points, and things called castles, the names of which were familiar, and where the mere surprise of seeing what one had so often heard of was a pleasure.... What an Archipelago it would be had it only due summer!"

Lord Cockburn, *Circuit Journeys*, 1842

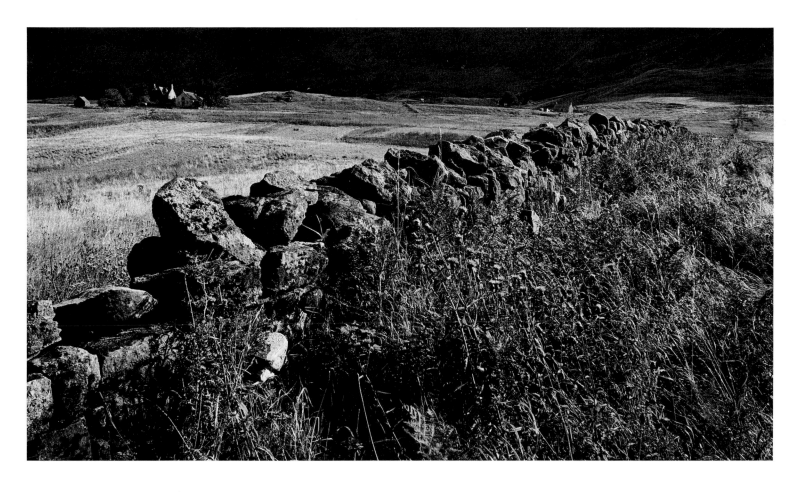

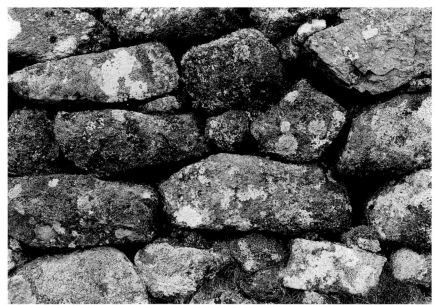

Walls, Cleadale, Eigg

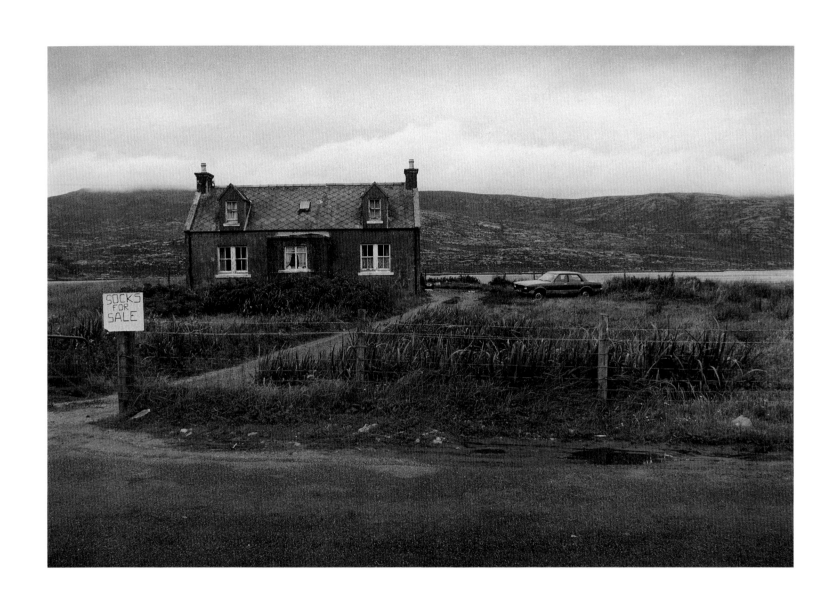

Cottage, near Seilebost, Harris

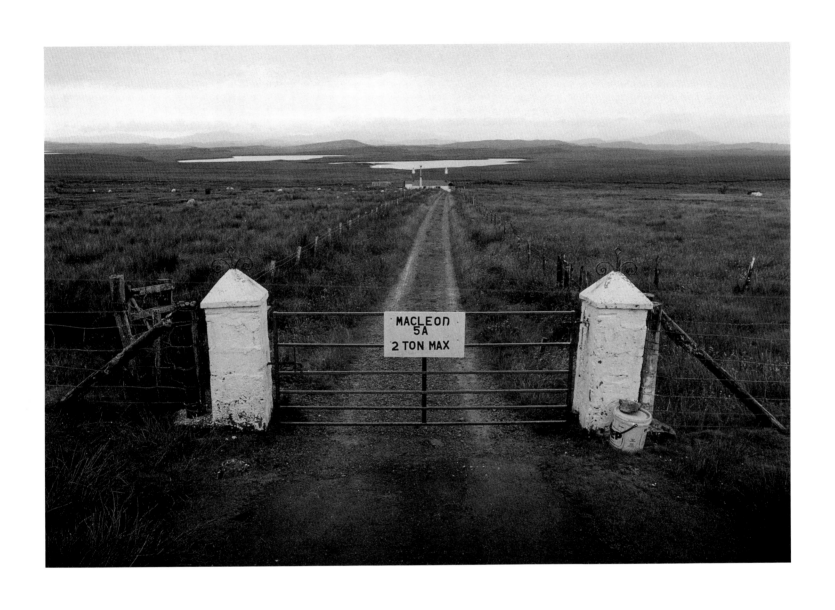

Gateway, near Callanish, Lewis

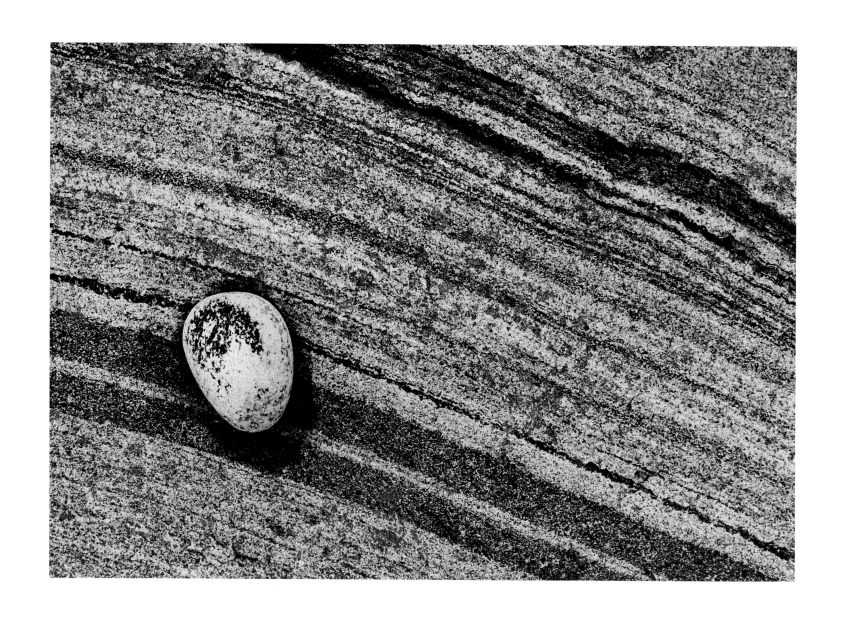

Stone on rock strata, Kilpheder, South Uist

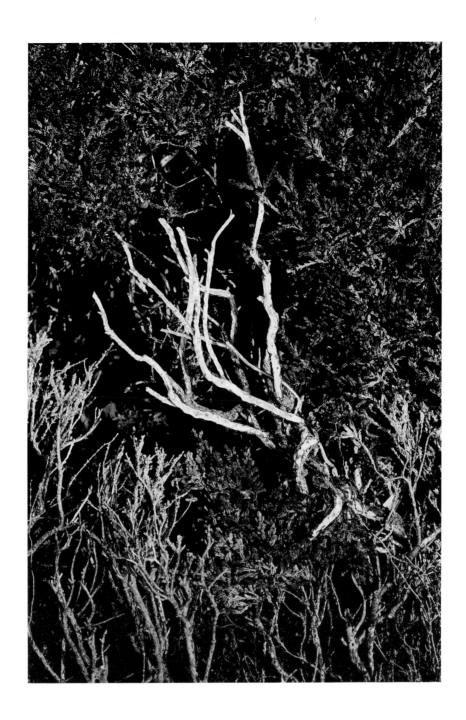

Bleached heather, Harlosh, Skye

"This makes a pleasant bed, vying in softness with finest down.... Heath naturally absorbs moisture and restores strength to exhausted nerves, so that those who lie down weary at night arise in the morning alert and vigorous. They all have not only a contempt for pillows and blankets, but choose to cultivate hardiness.... When they travel in other countries, they throw aside their host's bedclothes, fearing that these barbarian luxuries, as they call them, might affect their native hardiness, and so wrapping themselves around with their plaids, go to sleep."

George Buchanan, *Rerum Scoticorum Historia*, 1582

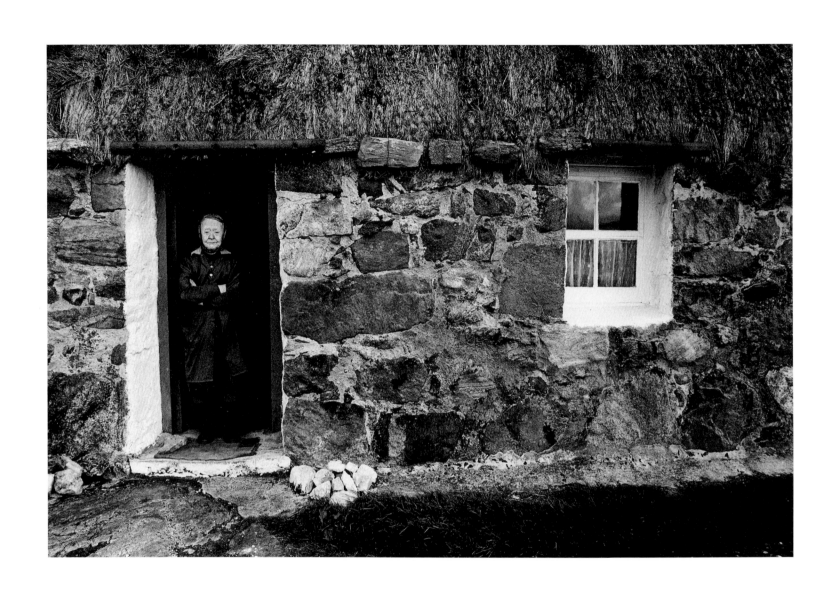

Cottage exterior, Mary MacDonald, South Lochboisdale, South Uist

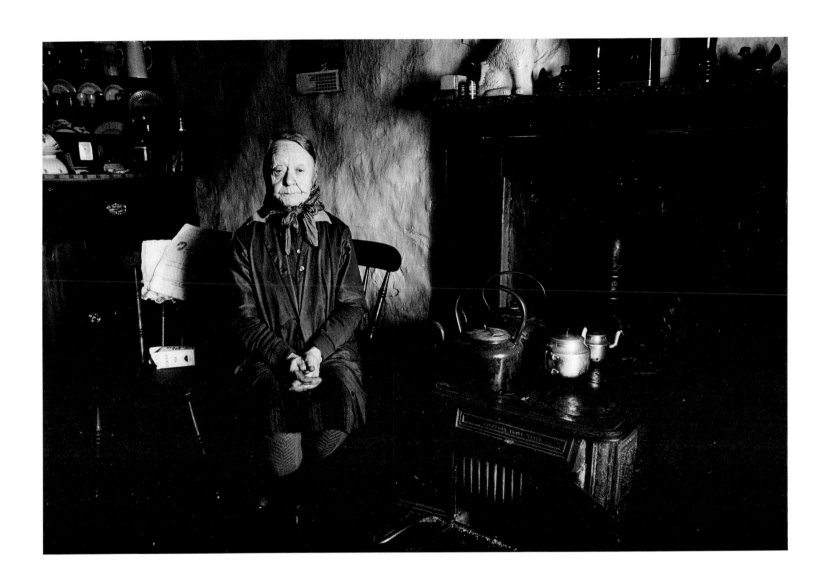

Cottage interior, Mary MacDonald, South Lochboisdale, South Uist

Mary MacDonald, a 'herring girl' of the 1920s, travelled extensively with the fishing fleets, gutting herring at various ports around the country: "I've been all over the globe – to Yarmouth, Peterhead, Lerwick...."

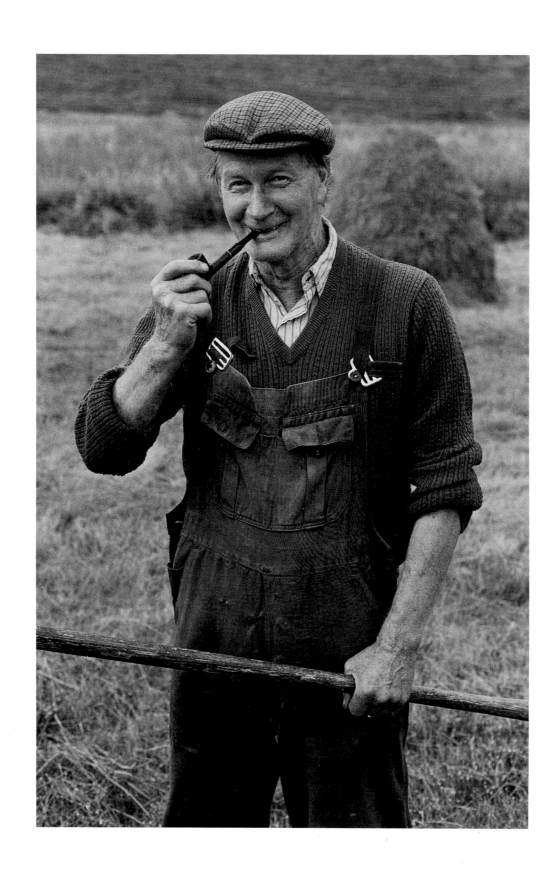

Duncan MacKay, Crofter, Cleadale, Eigg

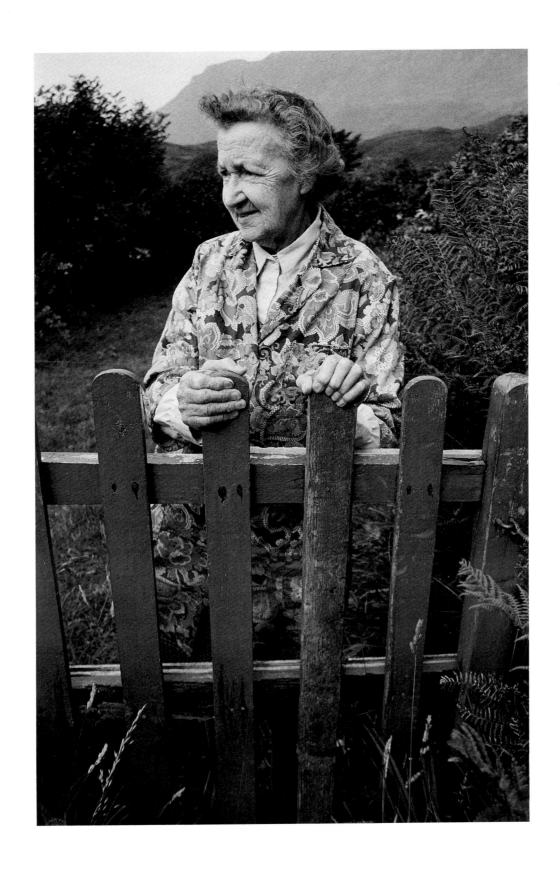

... and his sister, Kitty Anne

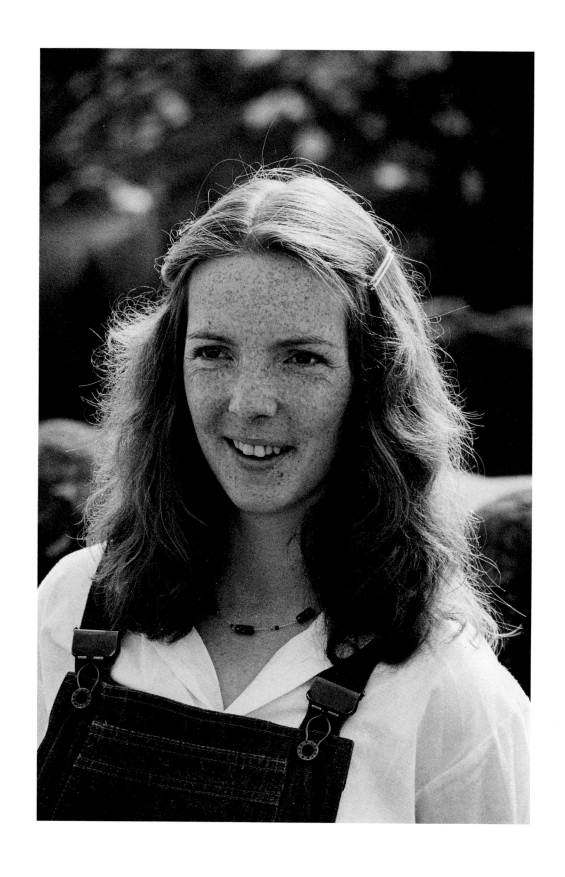

Marie Carr, Kildonnan, Eigg

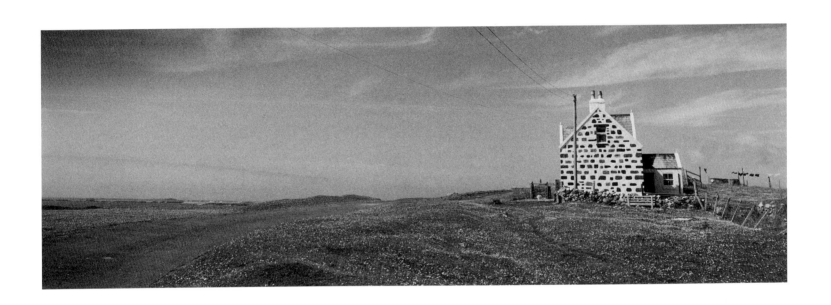

'Spotty house', Sandaig, Tiree

Tiree has been described as a living museum of croft houses, growing out of the unique flatness of its land. There are thatched houses, black felters, spotty houses, pudding and plain. Spotty houses are those built of stone, dormer windowed and with only the mortar painted, the stones themselves remaining uncovered.

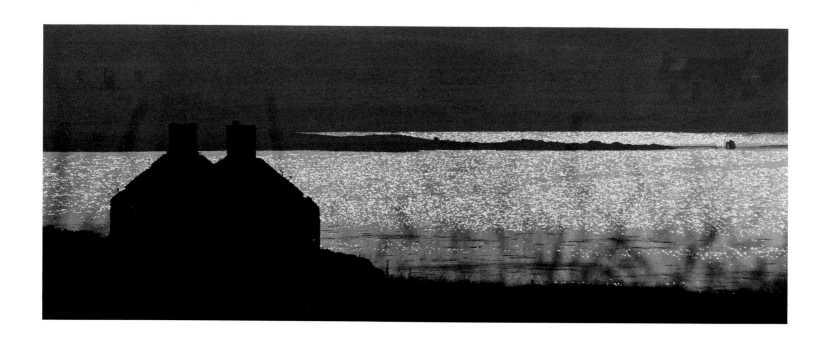

Derelict cottage, Sanday, Canna

"When the croft system was introduced, it was never intended that the people should prosper on the soil. The object nearest the landlords' hearts was to clear them from the soil, and if possible to sweep them from the country. If their purses had been as capacious as their hostility to the people, they would never have stayed their hand till every man, woman, and child was shipped to a foreign shore. But the expense of emigration was too much for their slender means and the project had to be abandoned. The croft system was then introduced as a temporary expedient to facilitate the clearances, and to afford a refuge to the outcasts until an opportunity should arise of transporting them to their allotted homes in Australia or Canadian wildernesses."

Robert Somers, *A Tour of Enquiry in the Highlands*, 1847

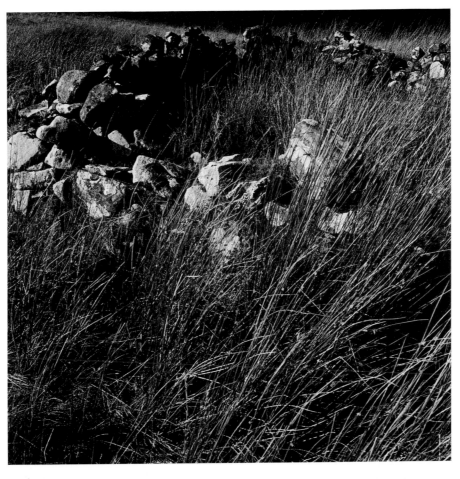

(top) **Ruins, Suisnish, Skye**

(below) **Gravestone, Cill Chriosd, Skye**

69

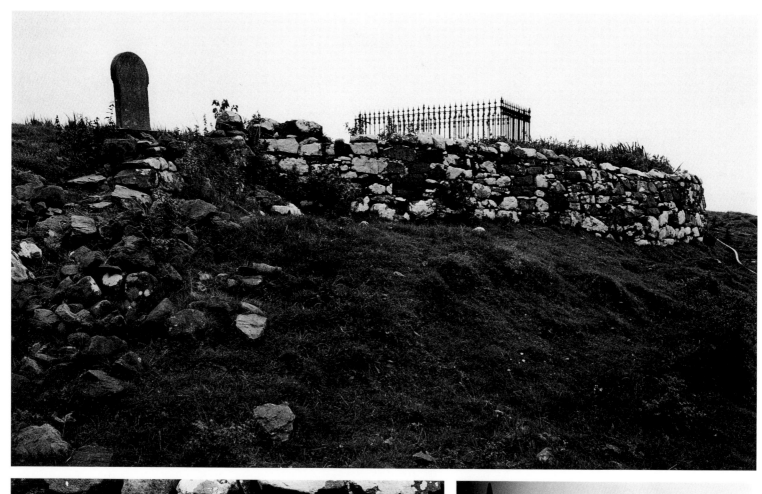

Burial ground, Kildonnan, Eigg

On this site in the year 617, St Donnan and
fifty-two monks were murdered by pirates
sent by the Queen of Moidart. Before his
arrival on the island, St Donnan had been
cautioned of "the red blood of martyrdom"
by St Columba, but the warning went
unheeded. At midnight after the massacre, it
is said that a strange light shone above the
graves and mysterious voices chanted the
words which have come down through
fourteen centuries:

The warm eye o' Christ on the tomb o' Donnan,
The stars so high on the tomb o' Donnan,
The warm eye o' Christ on the tomb o' Donnan,
No ill, no ill to the tomb o' Donnan.

"The people must not be permitted to forget that the Highlands are not their home – that they are only pilgrims – pilgrims from the interior glens of their native country to the wilds of foreign lands and that they are merely camping for a little while on the shore till the ships come and the winds blow that are to carry them to their destined place of abode. They must keep their lamps trimmed, and be ready on an hour's warning to set out on a long journey to the other side of the world. Why attempt to ward off the evil tendency of a system which is already doomed? Why make any effort to improve the condition of a people on the march to another hemisphere, and from whom we have nothing either to hope or fear? Leave them to themselves. Let them marry, subdivide and multiply till they are ready to eat each other up in the struggle for existence."

Robert Somers, *A Tour of Enquiry in the Highlands*, 1847

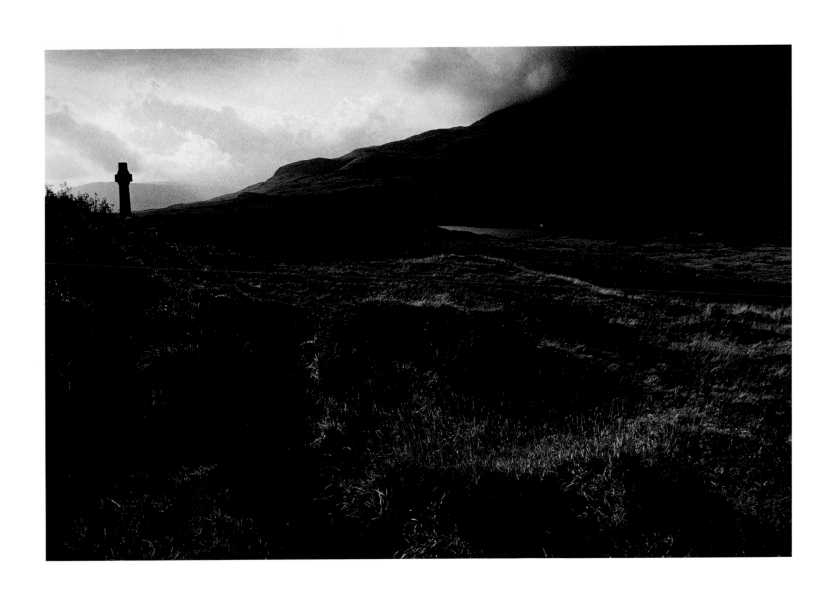

Burial ground, Cill Chriosd, Skye

Wall detail, Carsaig, Mull

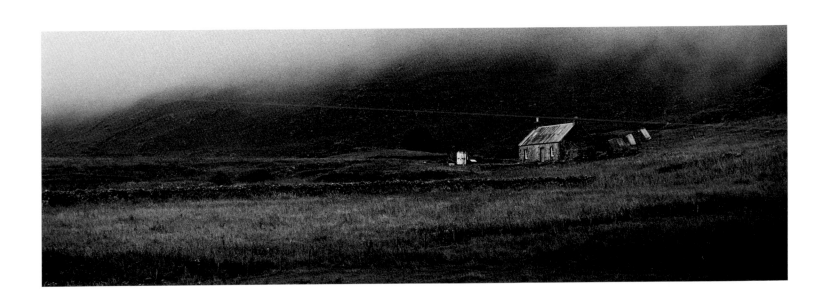

Croft cottage, Cleadale, Eigg

"As we continued to ascend, the thickness of the mist was terrible. Our guide began to talk seriously of his doubts and fears; assuring us that frequently people, going in search of cattle among the mountains were overtaken by these mists, and forced to sit quietly down, and wait for the morning. The situation forcibly impressed us with the truth of what he related; and we entered with a lively sympathy into the anxiety and despair, and vain struggles of those who are left thus to wander alone."

Robert Jameson, *Mineralogy of the Scottish Isles*, 1800

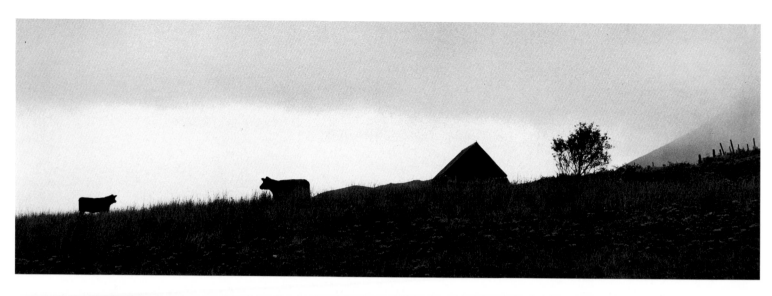

Evening, Laig, Eigg

Heather and rock, Balnahard, Colonsay

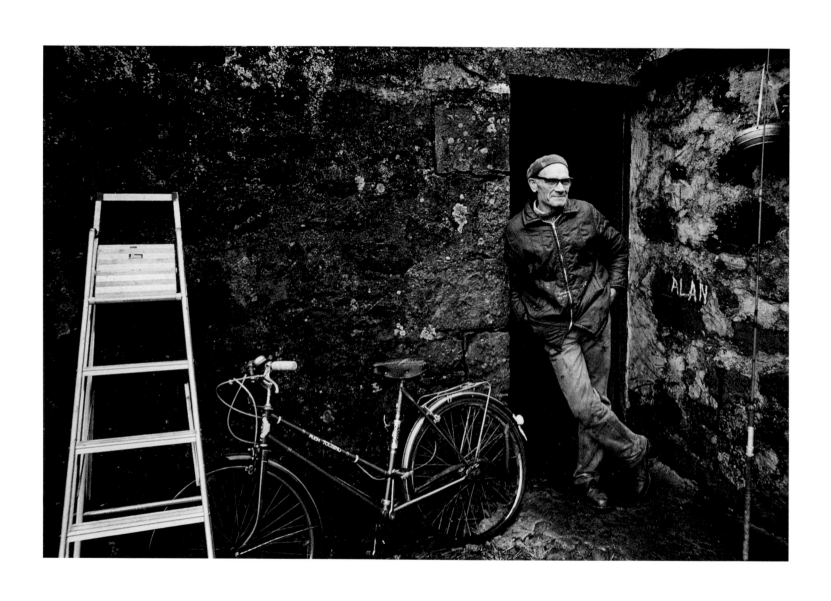

The late George Walker, handyman, Laig, Eigg

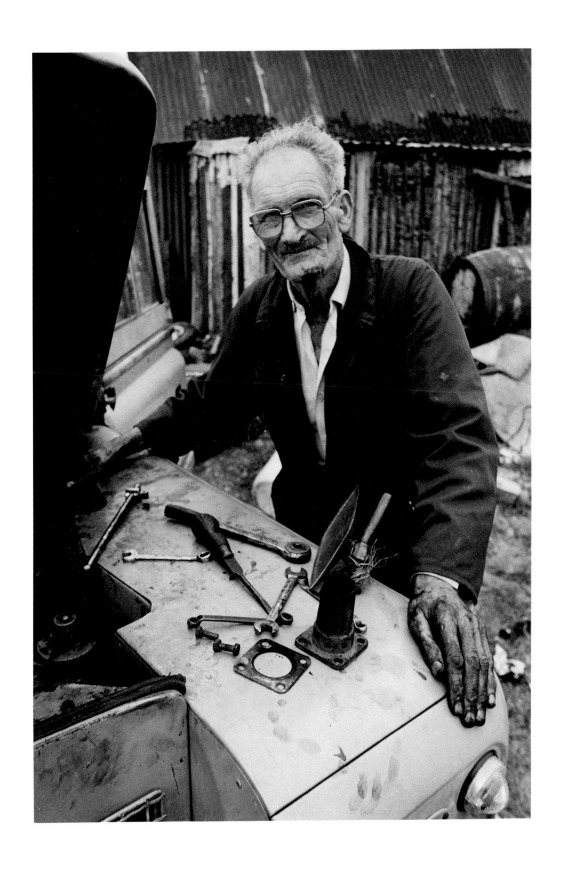

Dugald MacKinnon, taxi driver/mechanic, Cleadale, Eigg

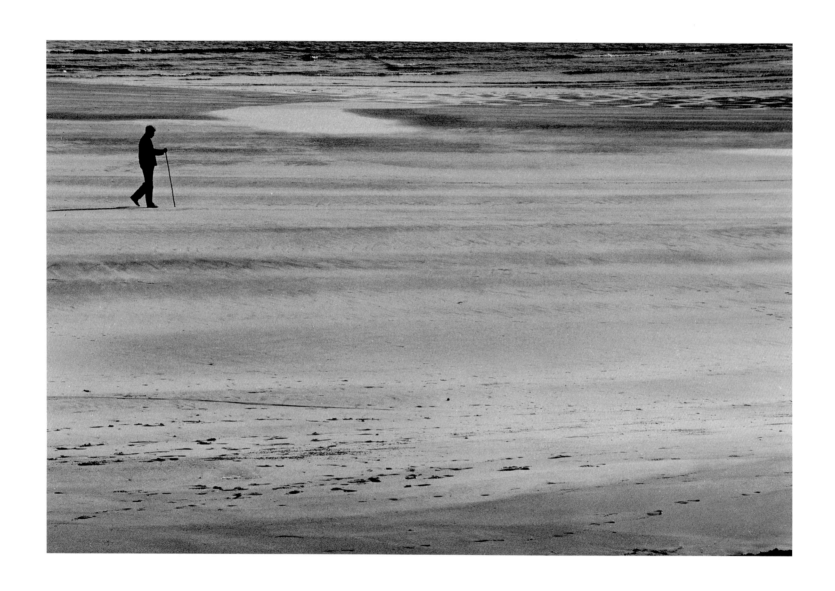

Father Hugh Barrett-Leonard, Laig, Eigg

From Brompton Oratory, London, Father Barrett-Leonard returns to Eigg whenever possible and is often actively involved in conducting the island's church services.

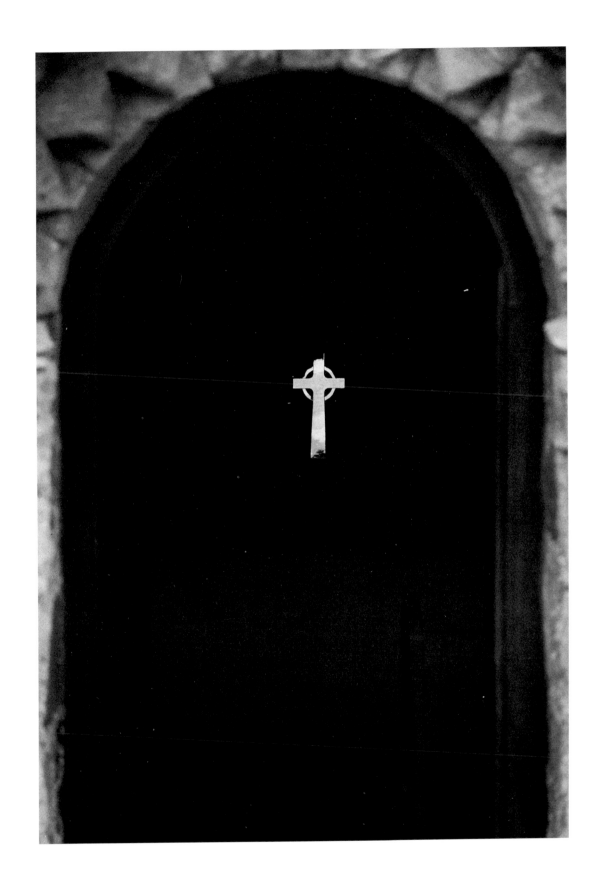

St Oran's Chapel, Iona

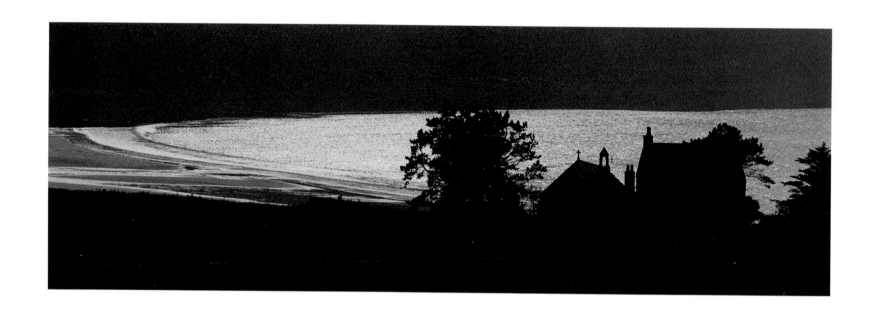

Chapel, Laig, Eigg

Built in 1910, the Roman Catholic chapel on Eigg is now in considerable need of repair. Years of exposure to the south-west wind and rain has left broken windows, crumbling render and mouldering plaster. Despite its condition, services are still held regularly. The distant sounds of sea breaking on the white Laig strands, cries of gulls and the bleating of sheep intermingle through the open doorway with the congregation's singing. A sense of peace pervades all.

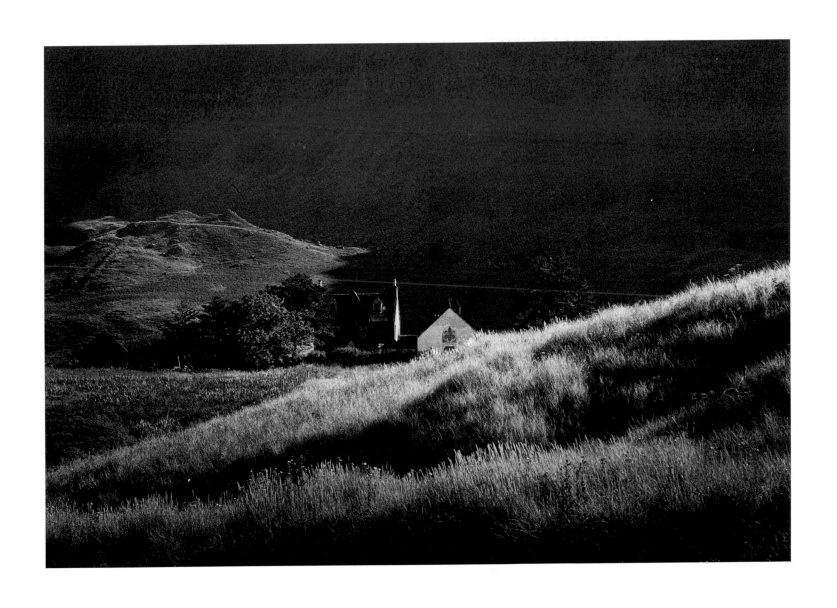

Chapel, Laig, Eigg

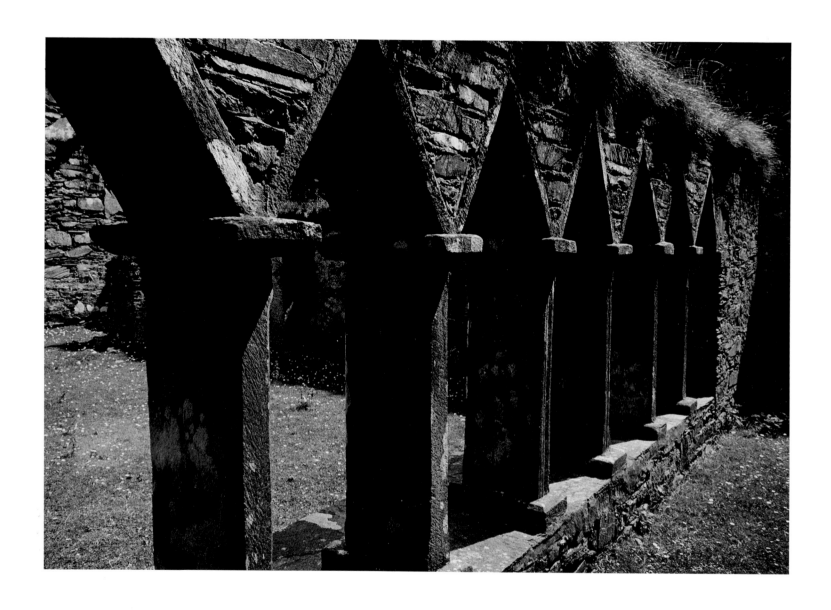

Cloisters, Oronsay Priory

The thirteenth century priory of St Columba was built on the site of a sixth century Celtic monastery. Remote and open to the wide ranging skies, the ruin is small and compact, the stonework beautifully carved and proportioned. Short close-cropped turf covers the floors, a carpet of daisy and harebell in the summer. The monks sleep peacefully here.

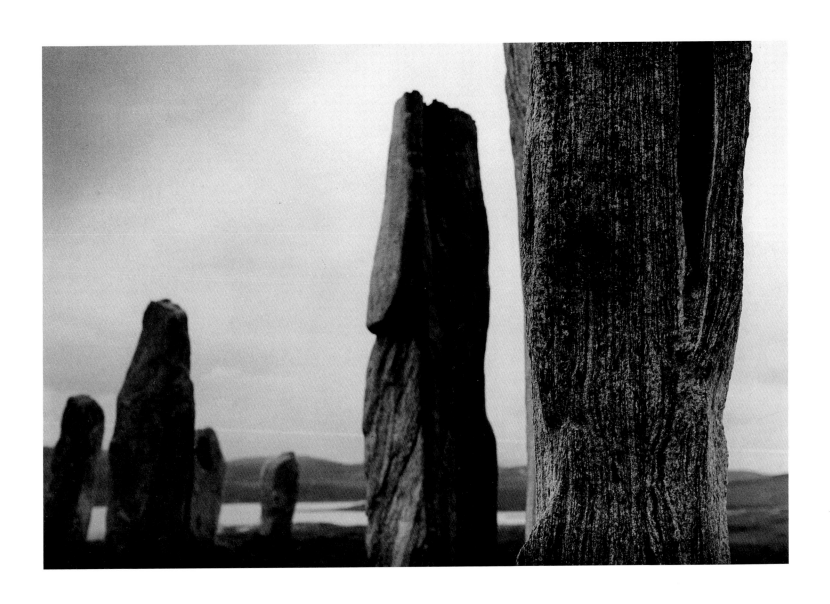

Stone circle, Callanish, Lewis

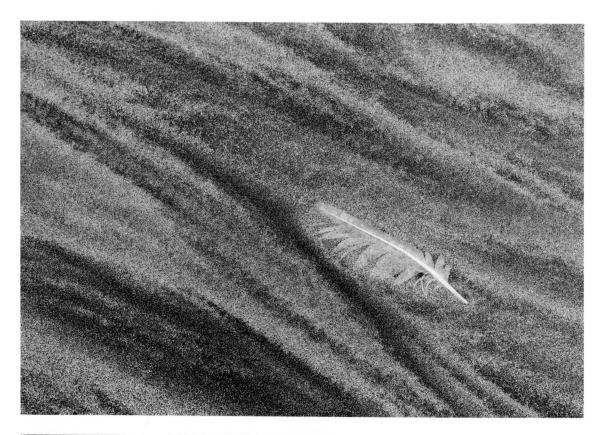

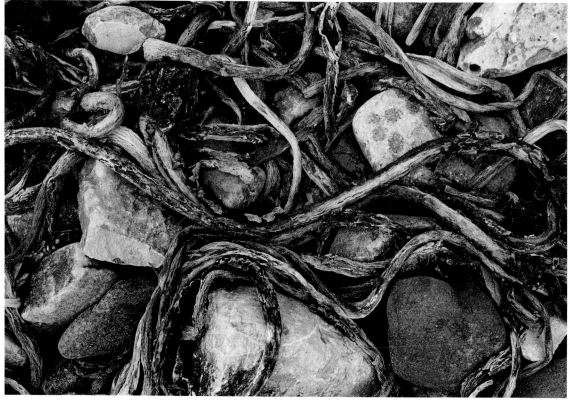

Beach details, South Uist

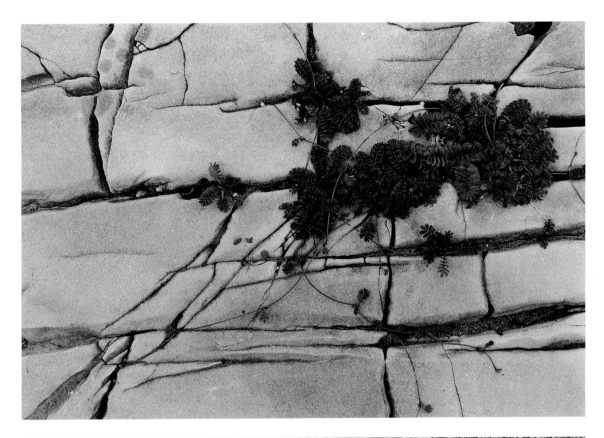

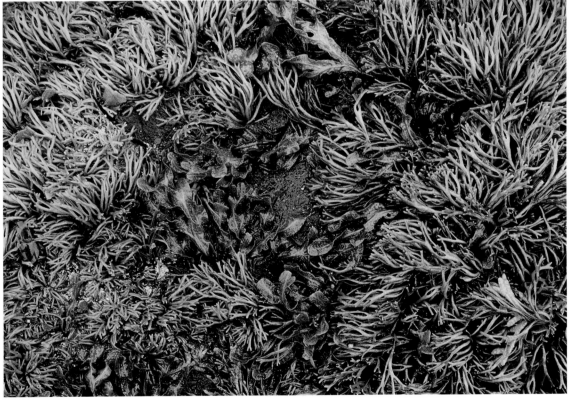

Beach details, South Uist

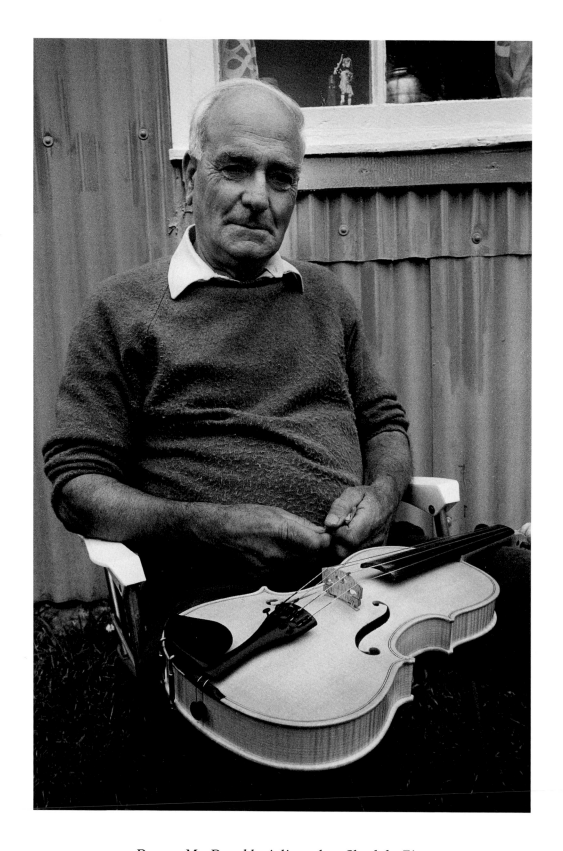

Duncan MacDonald, violin maker, Cleadale, Eigg

A self-taught maker of violins, Duncan's masterpieces have now been sold all over the country and played by many of the world's leading musicians. His interest is, however, purely in making the instruments: he cannot play a note or read music.

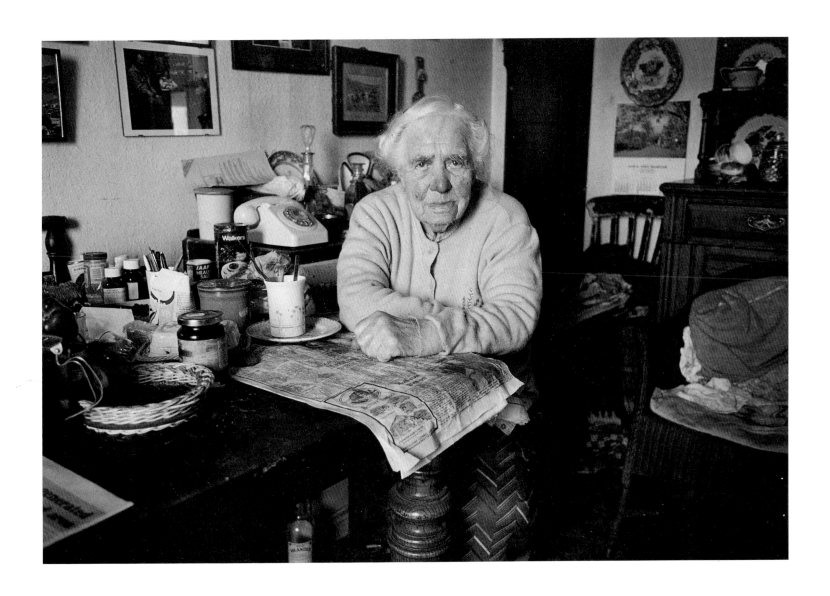

Chrissie MacGillivray, National Trust custodian, Burg, Mull

Chrissie MacGillivray lives at Burg Farm, Mull – 13 miles from the nearest shop. Now in her 90s, she is still custodian of the National Trust's Wilderness coastal area. Visitors to the famous MacCulloch's tree, a rare fossilised specimen preserved in an ancient lava flow at the foot of the sheer Wilderness cliffs, sign her visitors' book and seek her advice. She always makes sure that the same numbers that pass her cottage return after their visit to the tree. She realises, perhaps better than most, the hazards involved.

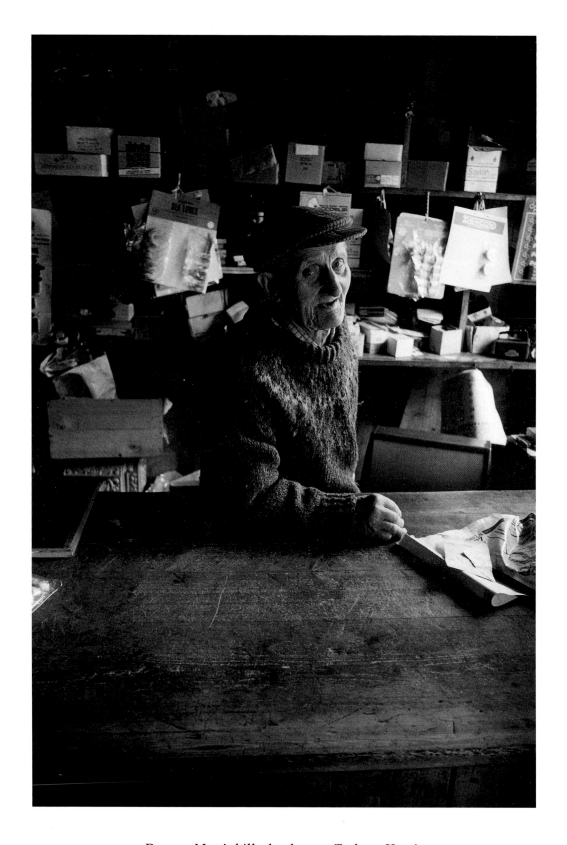

Duncan MacAskill, shopkeeper, Tarbert, Harris

In his 90s, Duncan MacAskill still runs his own general store in Tarbert. Returning as a survivor of the Gallipoli campaign of 1915, he has never left the island since.

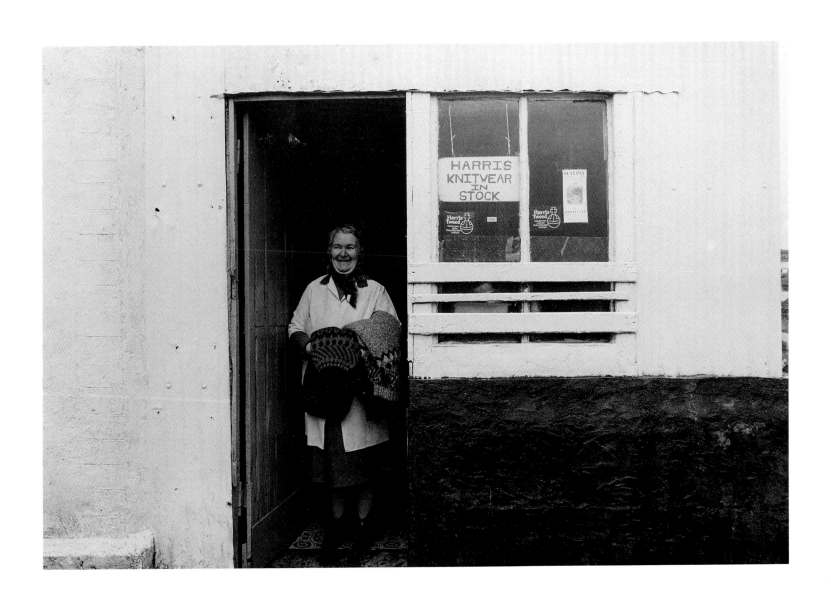

Shopkeeper, Scalpay

Happy memories of a short visit to Scalpay were of this lovely lady with an endearing smile and beautfully crafted knitwear

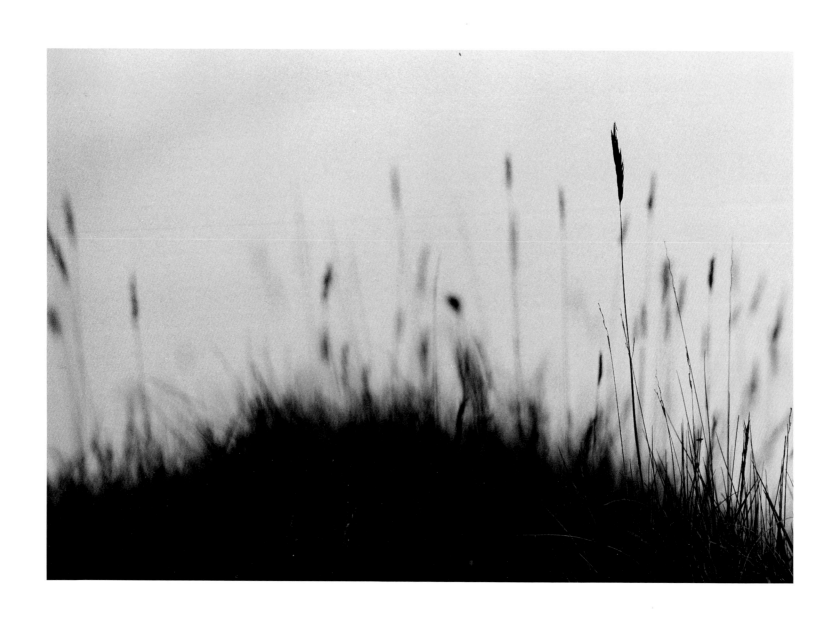

Grasses, Iona

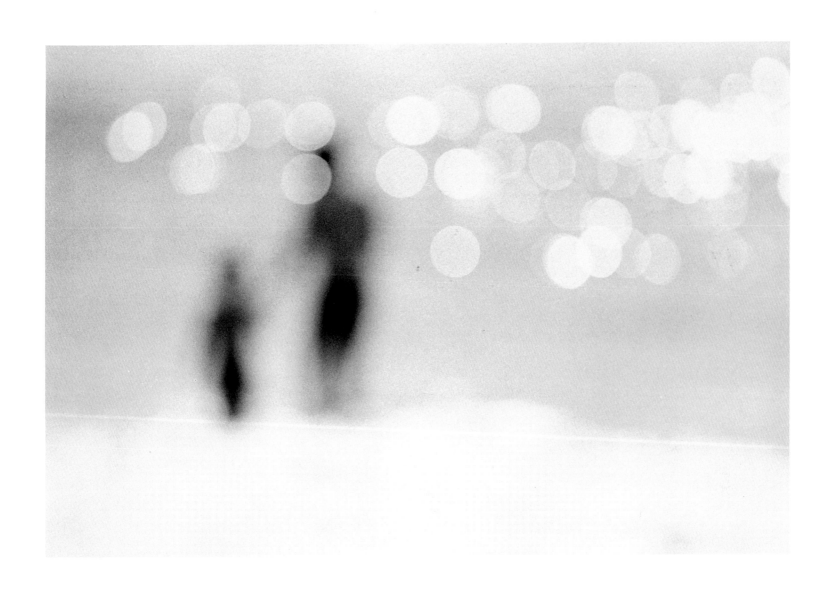

Summer bathers, Singing Sands, Eigg

One of those rare days when the temperatures do reach a respectable level and the sparkle of the sea, coupled with sheen-white sands, proves too much of a temptation

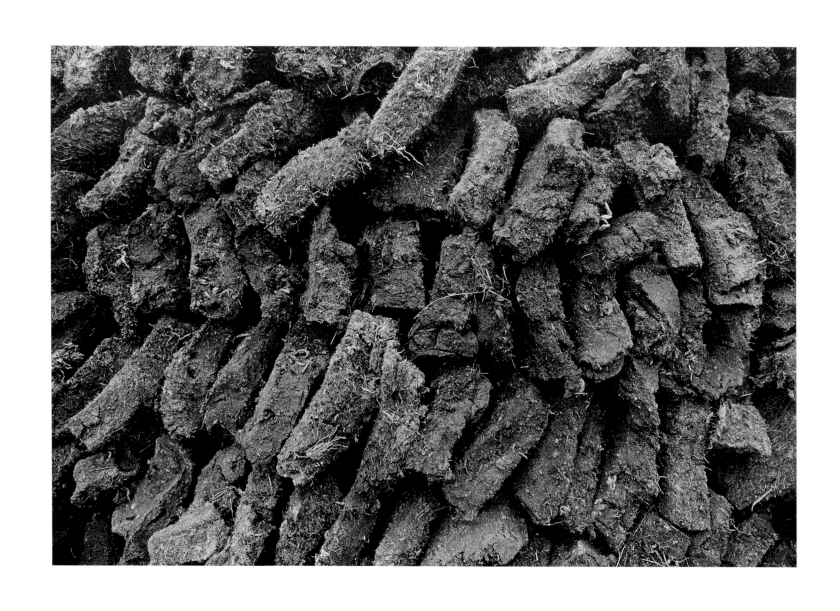

Peat stack, Scalpay

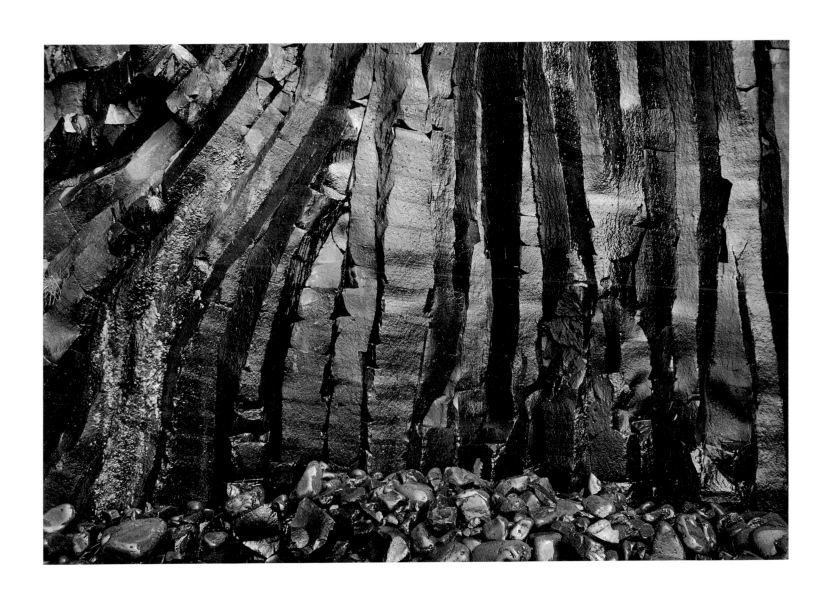

Rock formations, Burg, Mull

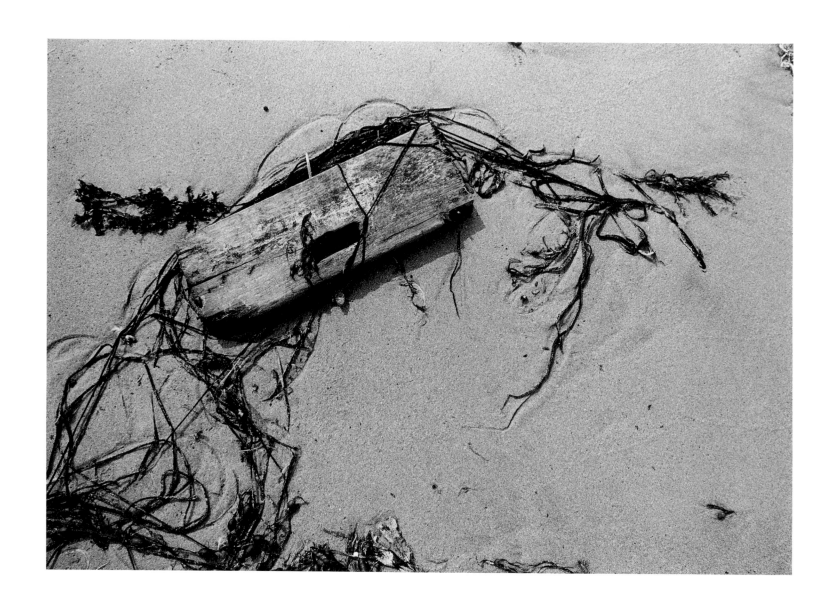

Beach detail, Calgary, Mull

"...several 60lb cheeses, tins of vaseline, cases of champagne, beans from the West Indies, a turtle from the sub-tropical seas, and an incandescent lamp quite uninjured! The vaseline was much appreciated by the natives who spread it in thick layers on their bread, and ate it with great relish."

Charles Peel, describing flotsam washed-up on a Hebridean beach, *Wild sport in the Outer Hebrides*, 1901

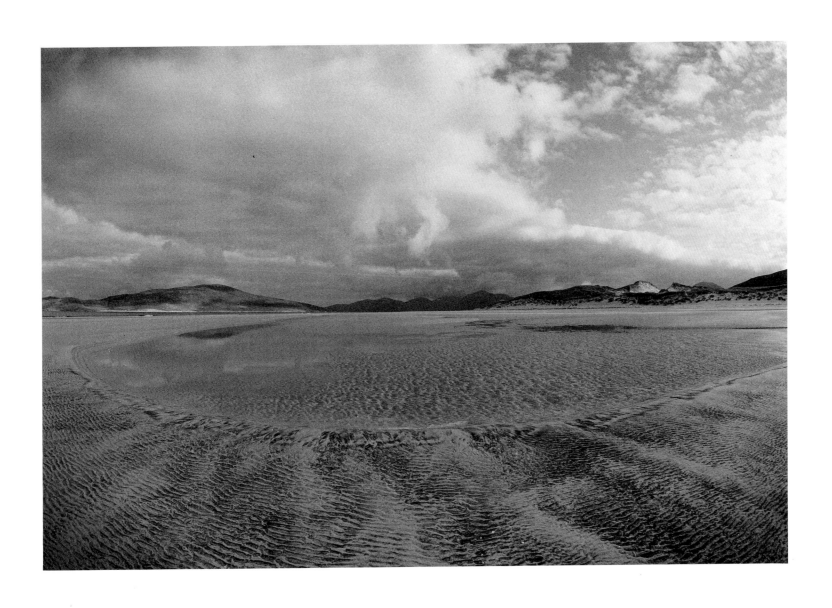

Towards Luskentyre, Harris

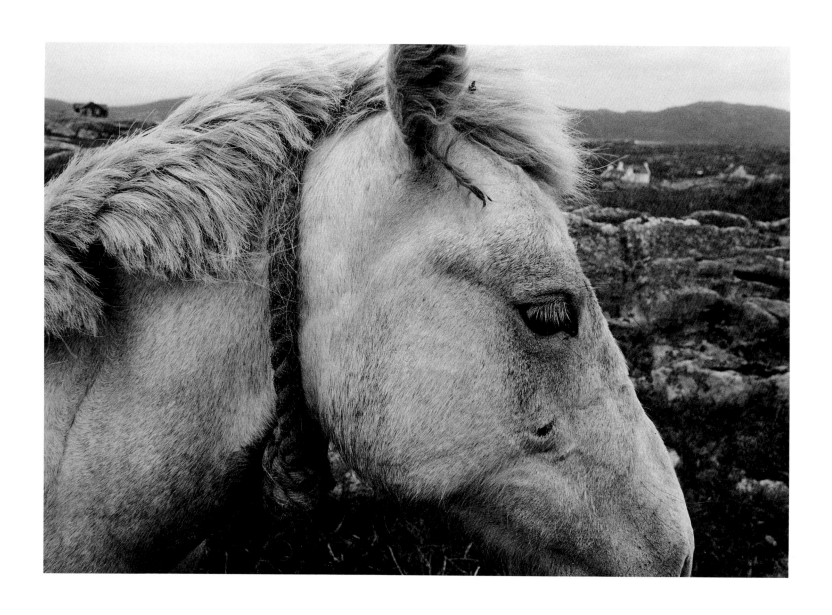

Tethered pony, Eriskay

It seemed strange to find this sad-looking beast tethered up among the open moorland of Eriskay: a stark contrast to the general sense of freedom within the island.

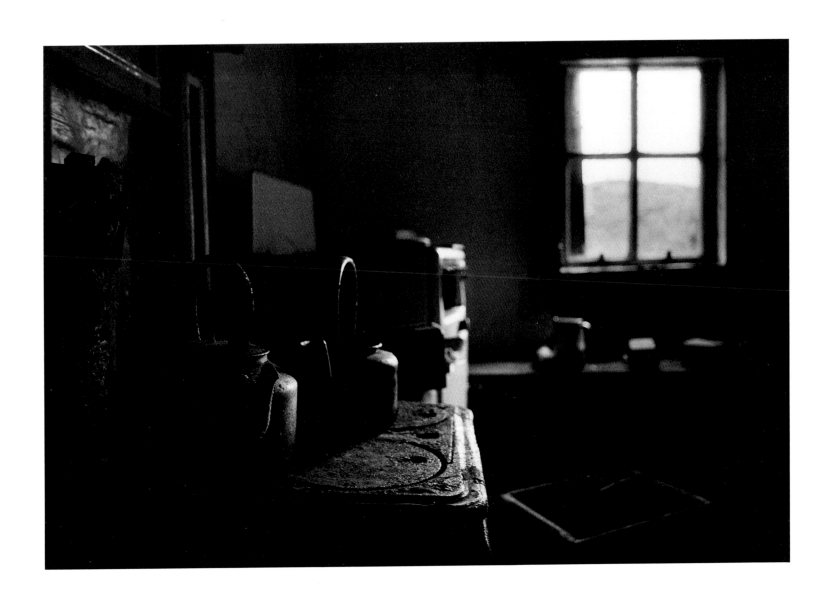

Cottage interior, Eriskay

Another sad impression of Eriskay. An abandoned cottage interior, the warmth of the kettles having finally died a long time ago.

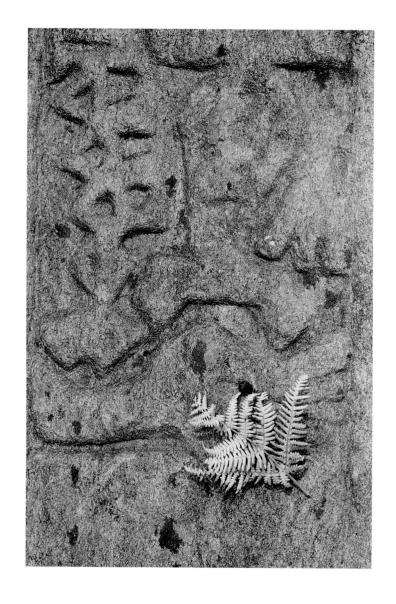

Stone carvings, Canna

"Some of the natives are very dextrous in engraving Trees, Birds, Deer, Dogs, etc. upon Bone, and Horn, or Wood, without any other Tool than a sharp pointed Knife."

Martin Martin, *A Description of the Western Islands of Scotland*, 1703

"Cannay... fair mane land, four mile lang inhabite and manurit, with an paroch kirk in it, gude for corn, girsing and fisching, with an falcon nest in it. It pertains to the Abbot of Colmkill."

Dean Monro, *A Description of the Western Isles of Scotland called Hybrides*, 1549

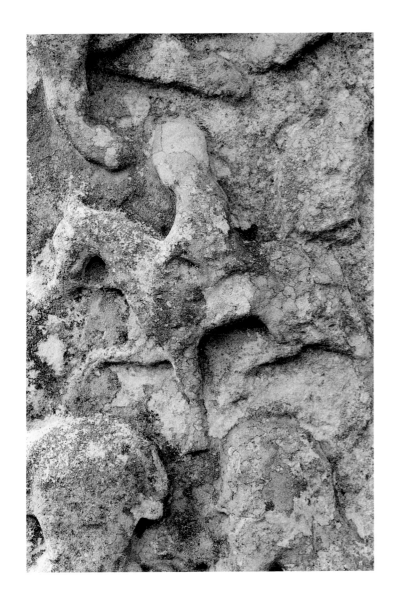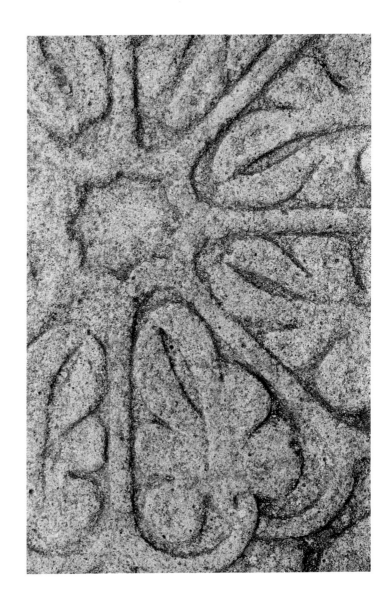

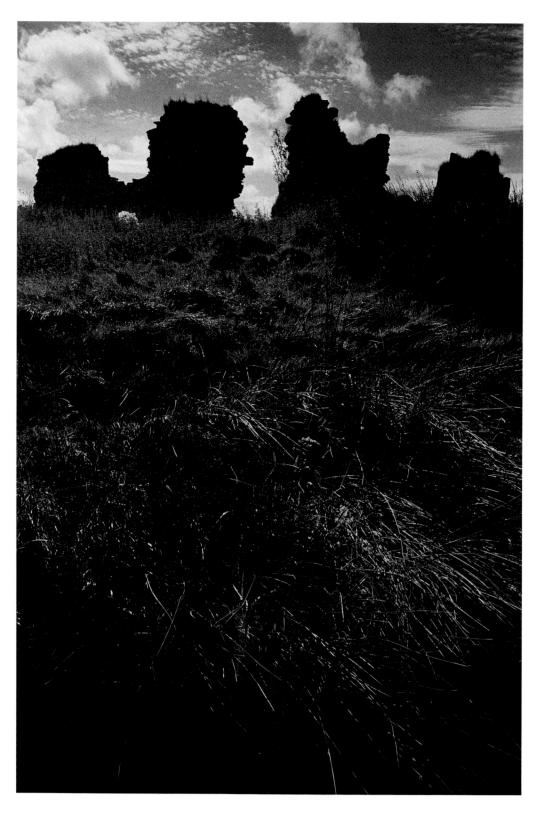

Knock Castle, Skye

Built by the MacDonalds in the fourteenth century, little now remains of Knock Castle except a few ivy-covered walls. Whilst surviving a seige by the MacLeods in the fifteenth century, it finally succumbed in later life to being used as a source of stone for the nearby Knock House.

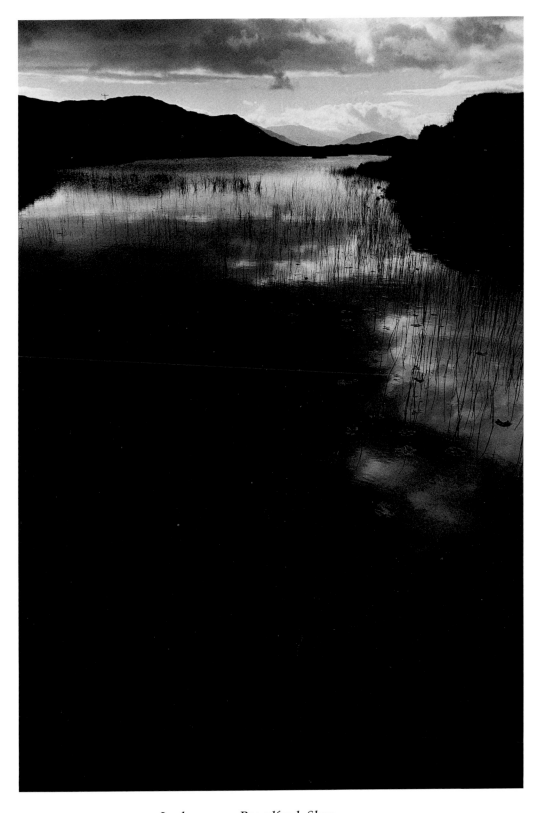

Lochan, near Broadford, Skye

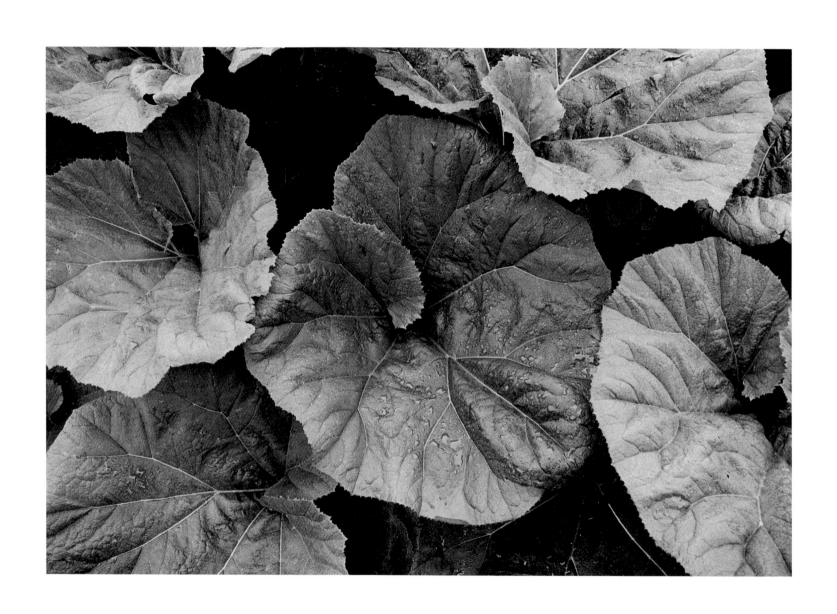

Butterbur, Gallanach, Muck

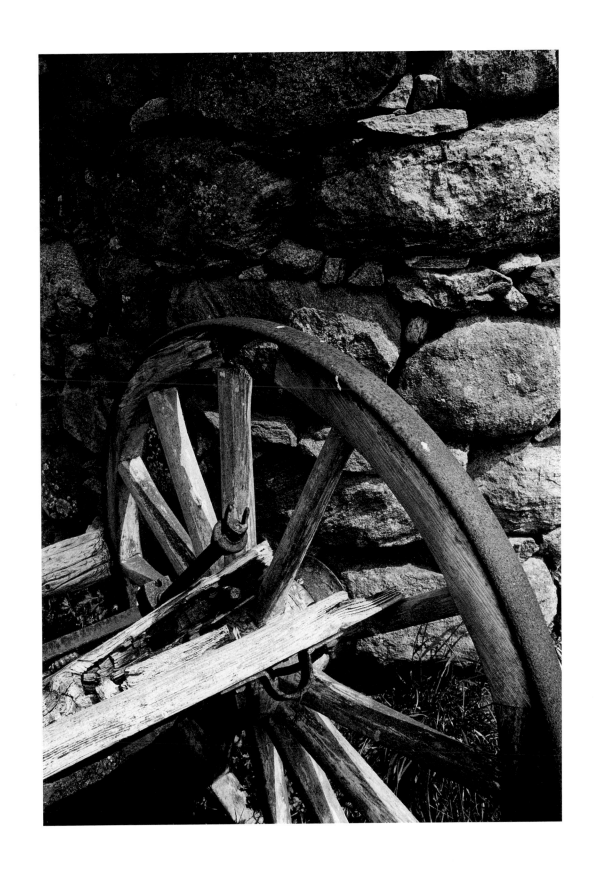

Cart wheel, Smerclate, South Uist

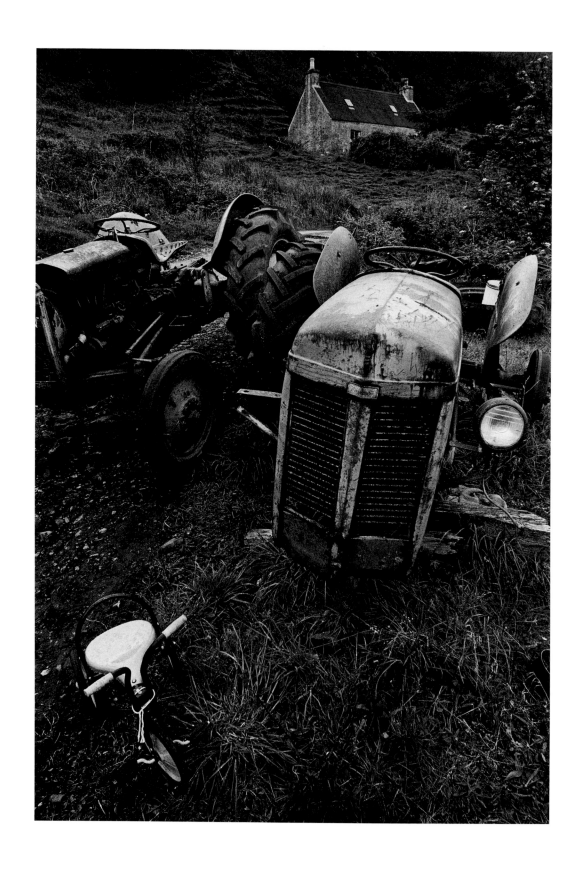

Tractors, Cleadale, Eigg

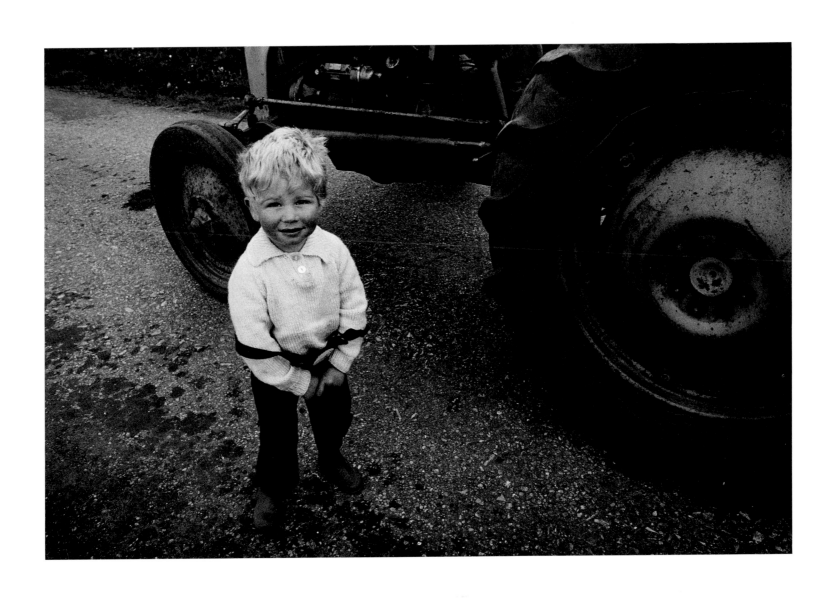

Tractor wheel and child, Cleadale, Eigg

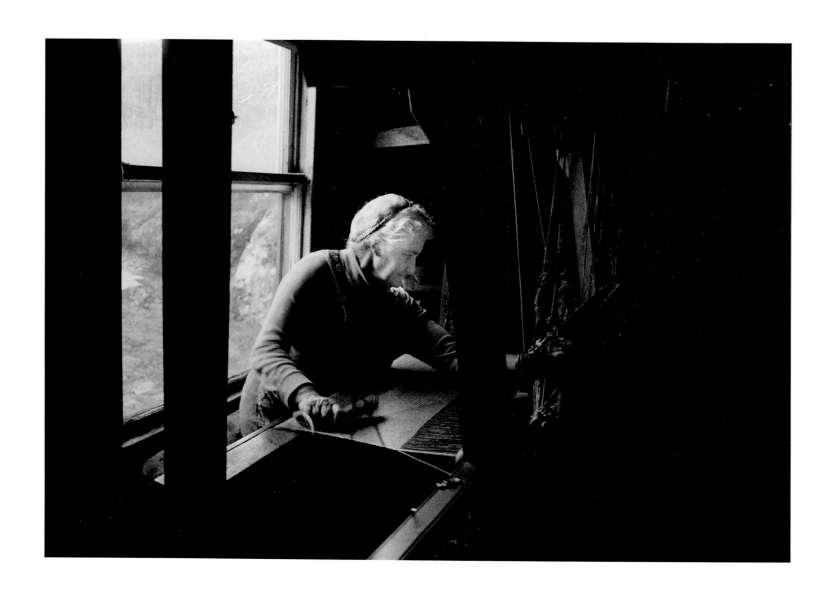

Marion Campbell, weaver, Plocrapool, Harris

At the time of taking these photographs, Marion Campbell was the last weaver on Harris still practising traditional methods of both weaving and colouring the wool from dyes and lichen. A wonderfully modest lady, working in equally modest surroundings, despite the ever increasing number of visitors wishing to make her acquaintance.

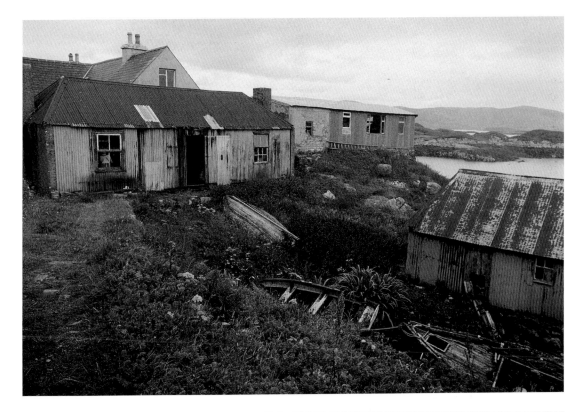

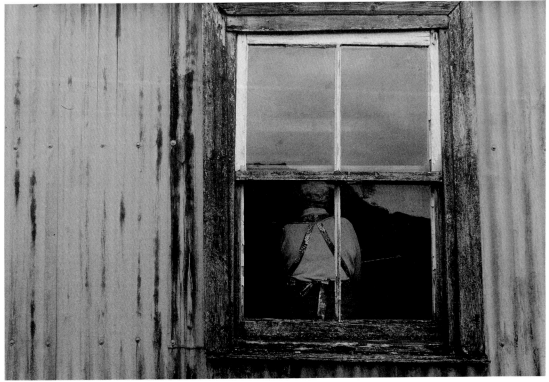

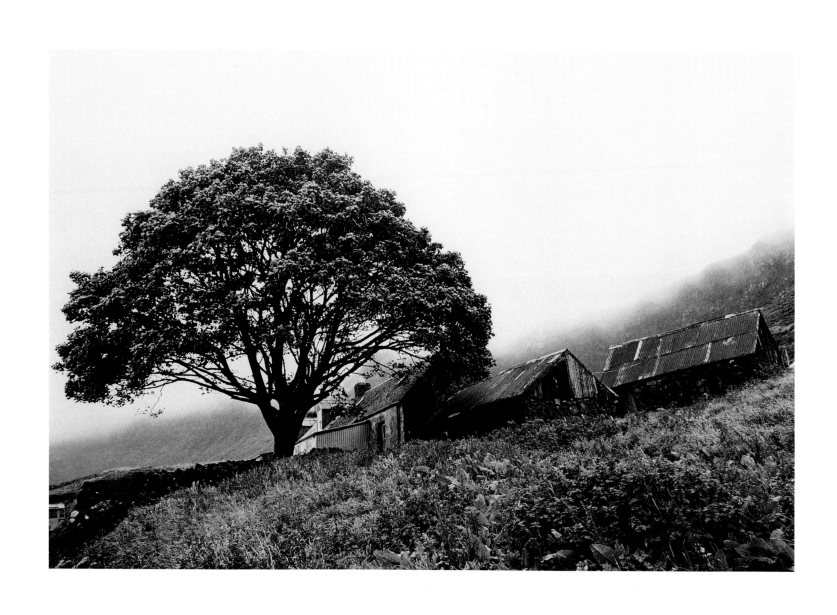

Tree and cottage, Cleadale, Eigg

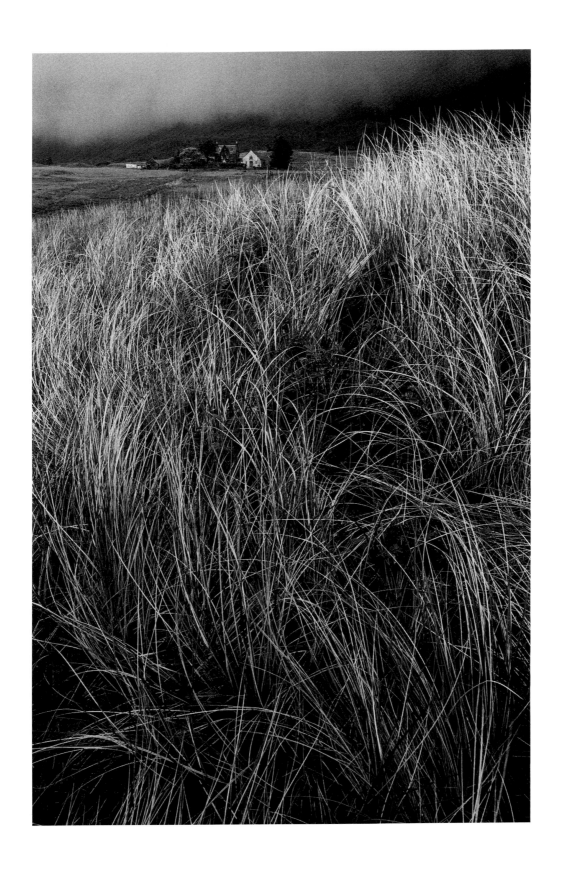

Marram grass and chapel, Laig, Eigg

"To all the crofters in Lorgill. Take notice that you are hereby duly warned that you all be ready to leave Lorgill at twelve o' clock on the 4th August next with all your baggage but no stock and proceed to Loch Snizort, where you will board the ship Midlothian that will take you to Nova-Scotia, where you are to receive a free grant of land from Her Majesty's Government. Take further notice that any crofter disobeying this order will be immediately arrested and taken to prison. All persons over seventy years of age and who have no relatives to look after them will be taken care of in the County Poorhouse. This order is final and no appeal to the Government will be considered. God Save the Queen."

Skye, summer 1830

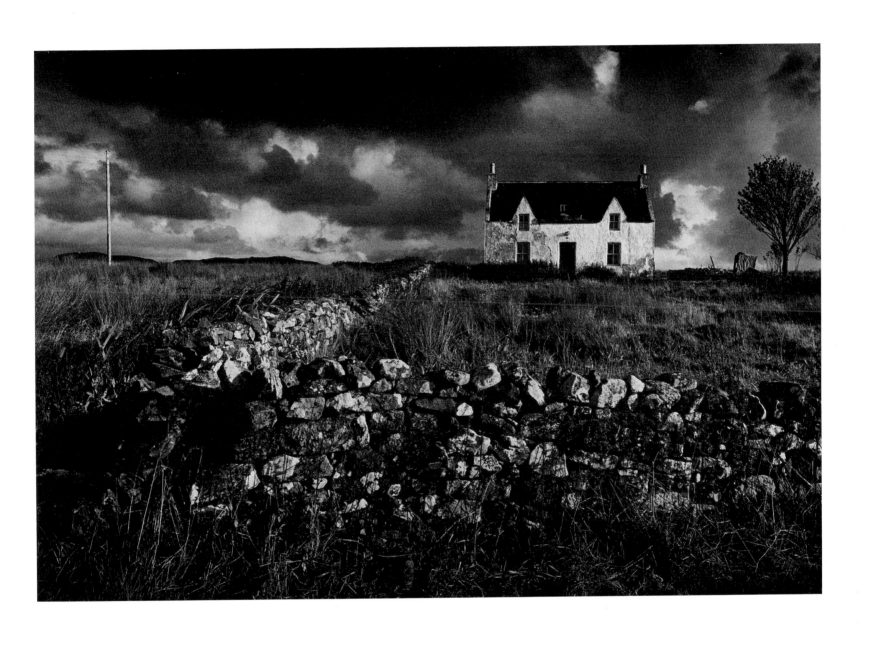

Empty cottage, Waterloo, Skye

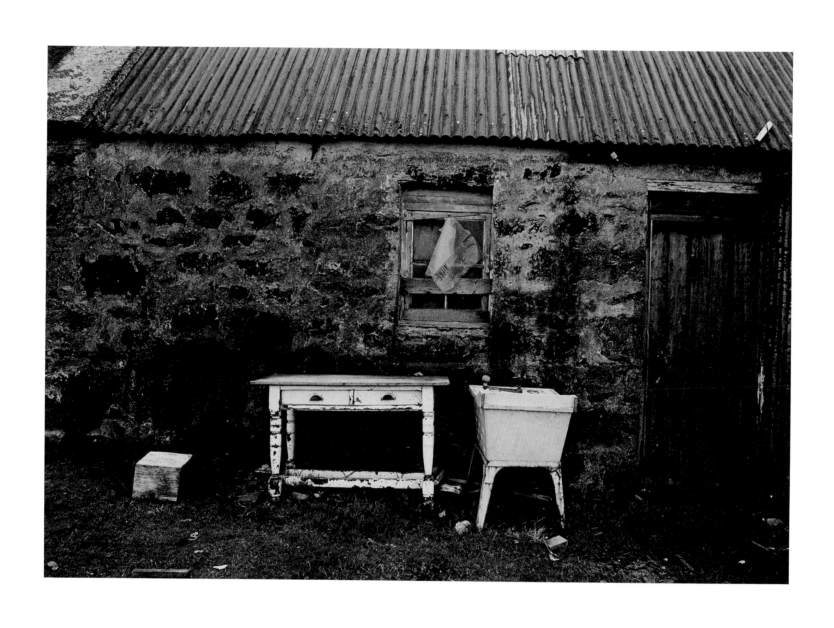

Discarded furniture, Howlain, Eigg

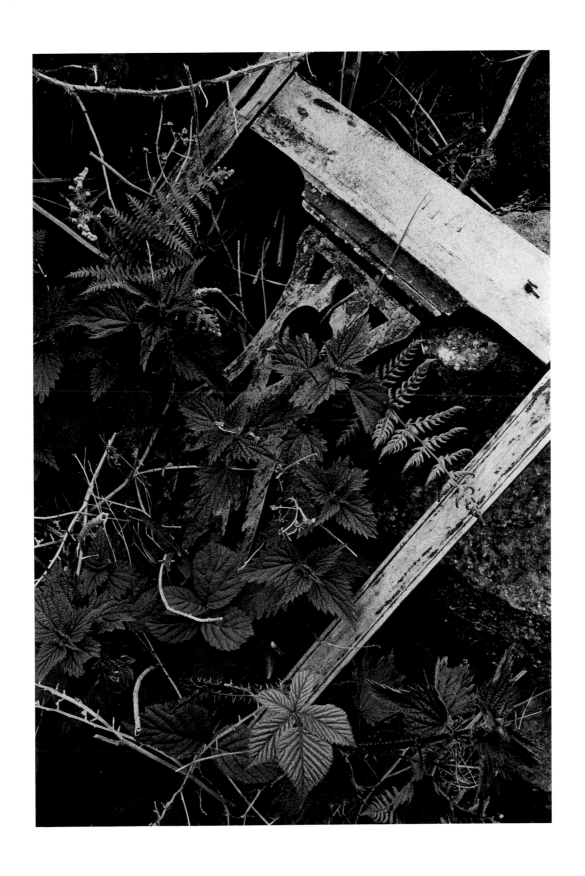

Chairback, Croig, Mull

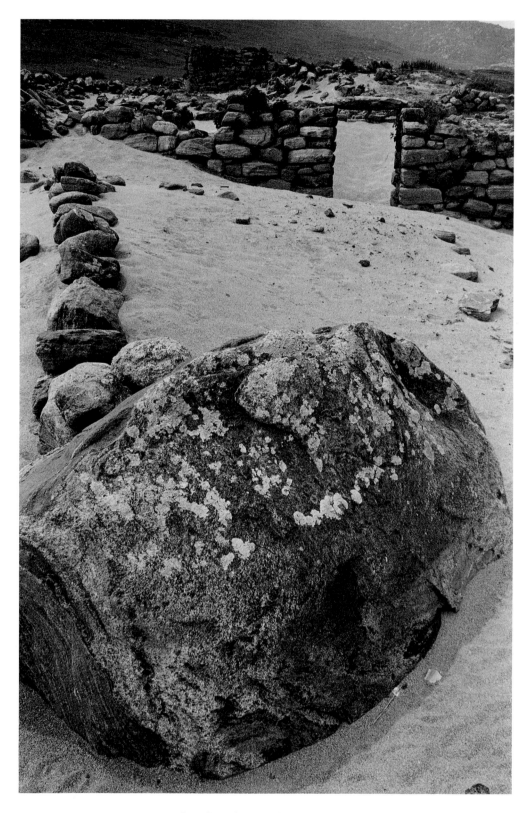

Abandoned township, Mingulay

Abandoned in the early years of the present century, all that now survives of a township once containing 150 people, are sand-engulfed stone walls with the ghosts of former inhabitants. This beautiful, empty, island signals clearly the fate that could befall so many small Hebridean communities, balanced on the knife-edge of survival.

Rock and cottage, Howlain, Eigg

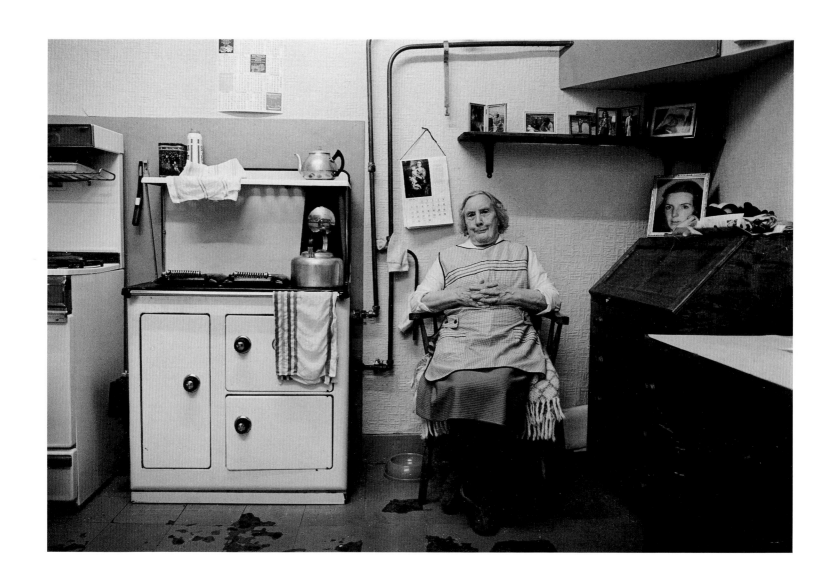

Mary Kirk, Laig, Eigg

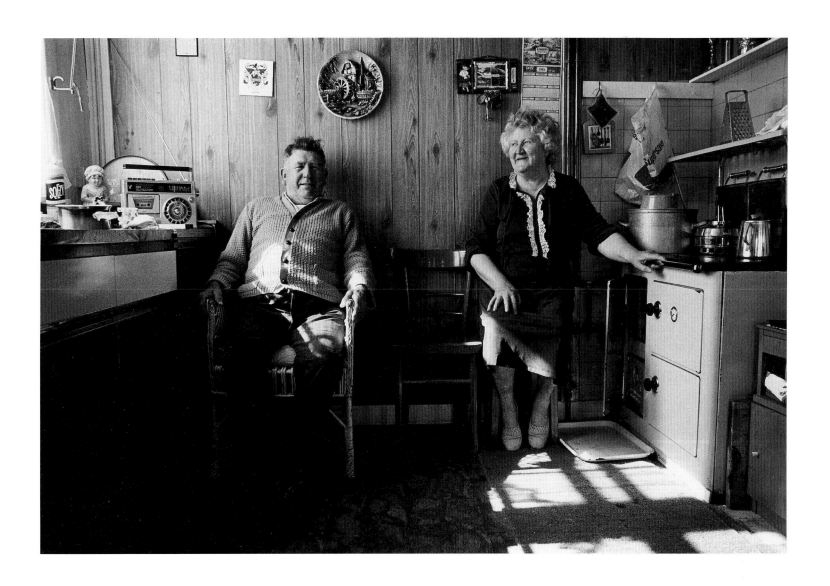

Mr and Mrs MacNeil, Borve, Barra

"The people are remarkably clean in their habits. Though far from woods their houses in general are more capacious and in every respect of a better description than the habitations of many of the same class in more favoured situations. Many of these have their chimneys and their glass windows, and their beds boxed with timber at the back, on the top, and at both ends; and all sweep and sand their earthen floors daily."

The New Statistical Account of Scotland, 1845

"A smack crossed from the Island of Eigg to the mainland once in the week, weather and inclination permitting, for the few letters and one newspaper brought by stage-coach from Fort William to Arisaig: about a fortnight later, somebody sailed across from Rum to Eigg to see if any letters had arrived... in the course of another week, more or less, a shepherd from the west side of Rum, looking for stray sheep, unexpectedly found himself in the seaport clachan of Kinloch, and while there might remember to ask if there were any letters for the neighbouring island of Canna; on the following day the folk of Canna saw a fire on a certain hill in Rum... and sometime before the end of the week somebody who probably never in his life received a letter sailed across the Sound and returned with the mail-bag as soon as he felt in the mood for returning."

Kenneth MacLeod describing postal
services to the Small Isles during the
mid-nineteenth century.

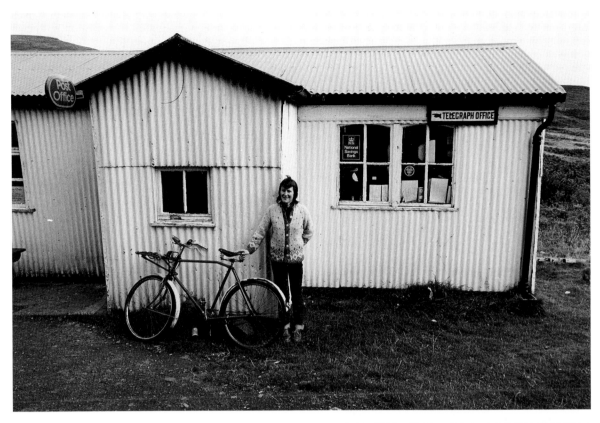

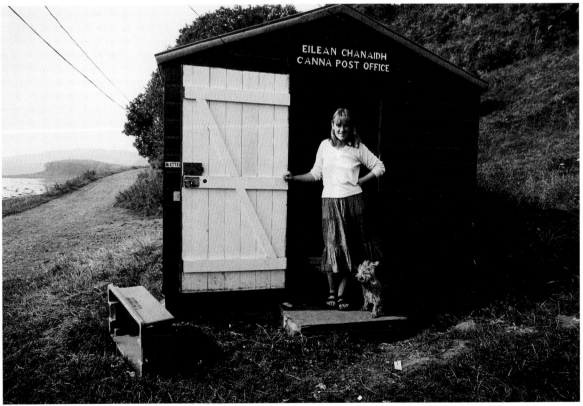

(top) **Mairi Kirk, postmistress, Eigg**

(below) **Winnie MacKinnon, postmistress, Canna**

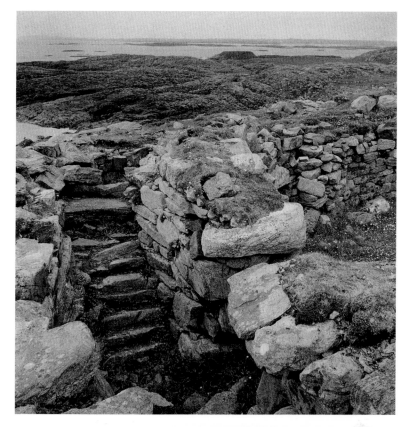

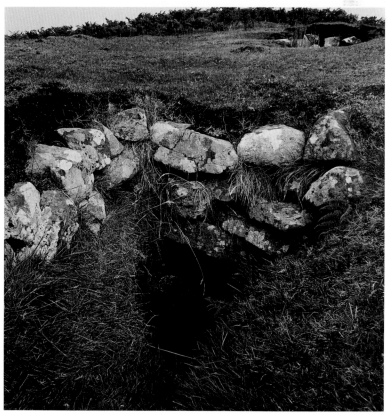

(top) **Dun Mor Vaul (a semi-broch), Tiree**

(below) **Souterrains (earth house or subterranean chamber), Canna**

The Celts built Dun Mor Vaul during the 1st century BC, probably as a communal refuge, later to be used as a farmhouse. Within the circular double stone walls, a series of galleries linked by staircases provided shelter when necessary. With their smooth outer walls only pierced by the entrance passage, brochs were almost impregnable and as such were one of the most successful types of building from the early Iron Age. Brochs, together with the earlier but simpler Duns (small fort on a mound), were built in their hundreds and inevitably sited and visually interlinked to give the widest prospect available on a given stretch of coast for defence purposes. For this reason, the sites are well worth visiting for the views alone. In most cases the structures have gradually been reduced to rubble over the intevening 2000 years.

Relatively few souterrains were constructed, mainly on Skye and the Small Isles. Normally tunnelled into the hillsides, they comprise a stone-lined passage ending at an inner chamber. It is thought they were used by the Picts firstly as refuges and later as granaries.

Summer, Eigg

"In the summer we began to live better. We got two cows to milk, and we began to provide for ourselves. We cut peats and dried them. We also commissioned a barrel of flour and a barrel of biscuit from Liverpool. In November we bought a cow and killed it for winter keep. Oatmeal was very dear, being at the rate of £1 8s. the boll. I went in a boat and bought six sheep, giving 4s. 6d. a-piece for them, afterwards killing and salting them. We also laid in our stock of butter and cheese for the winter; and fortunate it was for us that we were so provident, for the winter of 1784 was a dreadful one in the Highlands.*

Abram, 'Journal', *Inverness Courier*, 1854

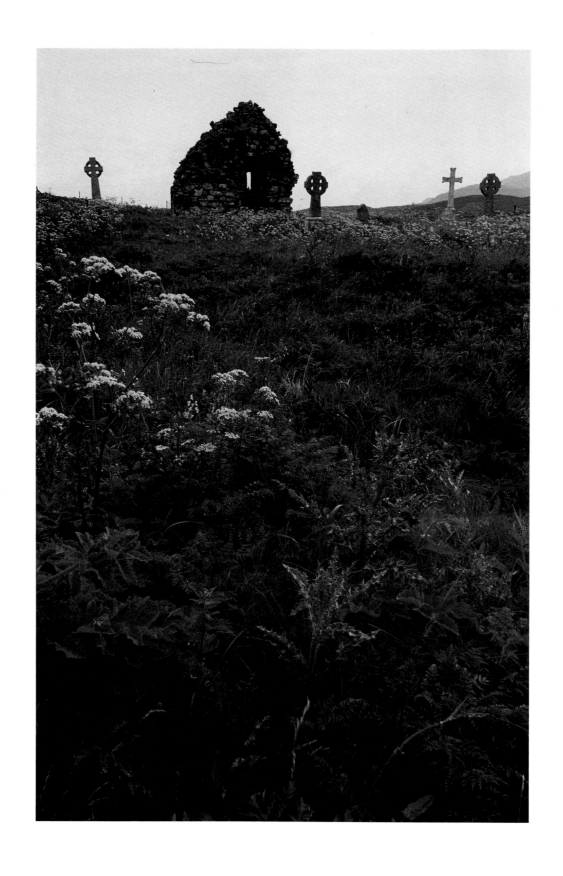

Chapel ruins, Howmore, South Uist

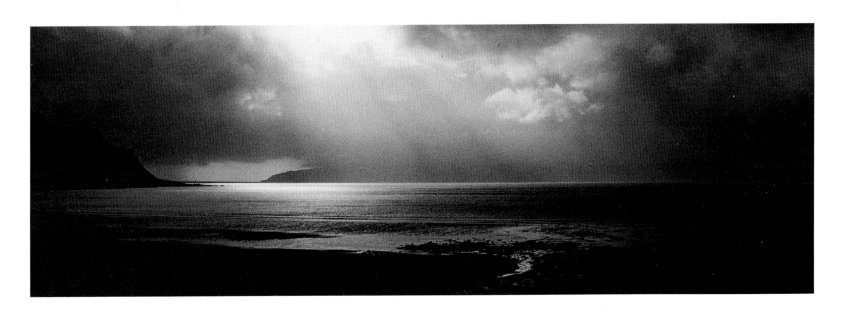

Towards Rhum from Laig, Eigg

"The evening was now approaching, and we were yet at a considerable distance from the end of our expedition. We could therefore stop no more to make remarks in the way, but set forward with some degree of eagerness. The day soon failed us, and the moon presented a very solemn and pleasing scene. The sky was clear, so that the eye commanded a wide circle; the sea was neither still nor turbulent; the wind neither silent nor loud. We were never far from one coast or another on which, if the weather had become violent, we could have found shelter, and therefore contemplated at ease the region through which we glided in the tranquillity of the night, and saw now a rock and now an island grow gradually conspicuous and gradually obscure."

Samuel Johnson, *A Journey to the Western Islands of Scotland*, 1774

Technical notes

I am a firm believer in keeping the mechanics of photography simple. The important matter is what is seen and selected through the viewfinder: the visual aspect rather than the chemistry and physics.

For all the pictures in this book, I used just one system, namely 35mm format in the shape of a rather ageing Pentax Spotmatic II camera with a choice of 17, 24, 28, 50 and 135mm lenses. Many of the pictures made use of an orange filter. The idea of humping medium or large format systems over the Hebridean peat moors (or anywhere else for that matter) has never had much appeal. I have generally avoided using a tripod, except for some of the interior shots.

I stick to a tried and tested film and developer combination, namely Ilford FP4 developed in Acutol for the extended period of 6.75 minutes. Usually I standardise on printing paper as well, using Kodabrome II RC in grade 4, using the hard paper to emphasise the nature of life in the Hebrides. For the book, I used grade 3 and printed marginally lighter than usual to give the printer a chance!

If you would like to receive a catalogue of Creative Monochrome's publications, please write to: Roger Maile, Creative Monochrome, 20 St Peters Road, Croydon, Surrey, CR0 1HD, England.